Anita Hörskens

EXPRESSIVE
ABSTRACTS
IN ACRYLIC

First published in Great Britain 2021 by
Search Press Limited
Wellwood, North Farm Road,
Tunbridge Wells, Kent TN2 3DR

© Edition Michael Fischer GmbH, 2017

www.emf-verlag.de

This translation of **ACRYL ABSTRAKT**, first published in Germany by
Edition Michael Fischer GmbH in 2017, is published by arrangement with
Silke Bruenink Agency, Munich, Germany.

English translation by Burravoe Translation Services

Picture credits:
Materials photo, page 12: © Schmincke GmbH & Co.KG
Drawings/Scans: © Anita Hörskens
Photos pages 9, 10, 51, 105, 143: © Anita Hörskens
All other photos: © Julia Wewerka – www.sternenstaub-photography.com

ISBN 978-1-78221-847-0

ebook ISBN: 978-1-78126-802-5

If you have difficulty in obtaining any of the materials and equipment
mentioned in this book, then please visit the Search Press website for details
of suppliers: www.searchpress.com

Anita Hörskens

EXPRESSIVE ABSTRACTS IN ACRYLIC

55 innovative projects, inspiration and mixed-media techniques

SEARCH PRESS

Contents

FOREWORD

Abstract painting (Latin: abstrahere; draw off from, separate) is a collective term for various trends of non-representational painting which do not evoke any memories or contain any references to visual reality. Abstract art has established its place in the art scene all over the world through ever-changing mutations and stylistic directions. For example, in Europe, Tachisme developed firstly in France, a spontaneous application of splashes of paint without any consideration to compositional principles, to be followed by Art Informel. The latter is a wave which promoted a completely 'shapeless art', which rejected both geometric forms as well as the abstract rendering of physical objects.

In abstract expressionism, intellectual concepts are cast aside in favour of a spontaneous creative process and large-scale gestures. The result of this instant, rapid way of working is an artwork which ideally comes about without any control by the intellect. What all these waves have in common is an overcoming of a representation that is based on reality. Only the medium, colour, space, line and form count, their composition and texture coming to the fore.

Years ago, I enjoyed an extraordinary audio-visual tennis lesson, based on an autogenic training approach. Knowing that a successful shot consists of a number of consecutive processes which must all work, one after the other, you concentrate on just one particular process of the shot. For example, in one part of an exercise, where the aim was to not let the ball out of sight, there was an almost imploring instruction, repeated over and over, 'you only see the ball, nothing but the ball'. All of the other processes at this moment were to be carried out unconsciously, but were not the focus of attention.

This training left such a lasting impression on me, that I am dividing this book into similarly sequenced lessons. In the accompanying exercises, I also just focus on one individual aspect, in the full knowledge that just one single approach will never lead to a good picture. In this way, the individual parts of the 'Building blocks of Possibility' will become ingrained in you, to be recalled upon at some point and combined in a playful way. With the courage to experiment, you will strengthen your intuition and, in time, develop your own original way of working.

ABSTRACTION

ABSTRACTION OF REAL OBJECTS

In abstract pictures, objects and elements of the material world serve as a point of departure. Without adhering to depiction in the usual sense, these models are converted into an extremely personal interpretation, where they are taken out of their natural context or are changed beyond recognition. So, for the abstraction of a real object, remove the perspective. Let yourself be taken in by the detail in your environment and observe untouched nature just as much as elements created by the human hand. Respond mindfully to the details, with regard to colours, spaces, forms, lines and textures.

To create the abstraction of a physical model, reduce what is seen into simple forms in the first sketches, or just use sections of the entire model. While painting, concentrate on what is developing on the canvas, and forget the original source of inspiration.

For example, you can abstract by:

- omitting details
- refraining from perspective, light and shade
- rendering in two dimensions
- simplifying forms
- choosing an unrealistic colour.

Inspiration and transformation

As examples of inspiration from your environment, the following photos taken during a walk offer an abundance of ideas. The photos have already been taken with regard to the compositional aspects and are transformed in the corresponding sketches. You can also use the information about the primary elements of the image contained in the painted versions and transform these accordingly.

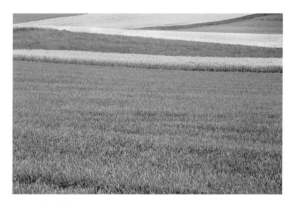

Spring fields – space, colour

Spring fields – space, colour

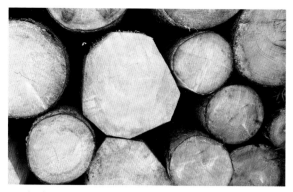
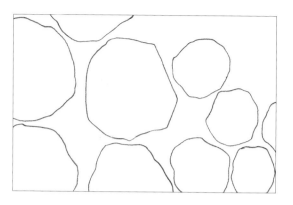

Stacked tree trunks, form

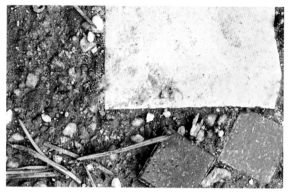
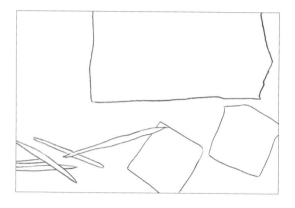

Mosaic stones on the edge of the path – form,
colour, texture

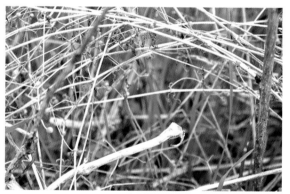
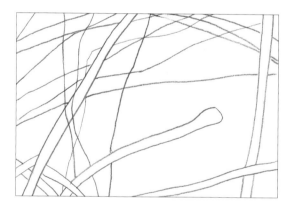

Dried stalks – line, form

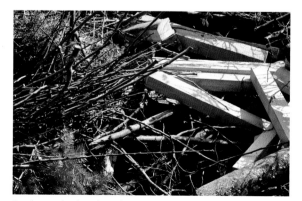
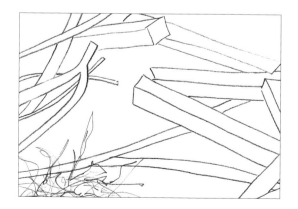

Brushwood pile – line, form

ART INFORMEL

Art Informel is a collective term for the stylistic directions of the twentieth century which include both Tachisme as well as Lyrical Abstraction. In Art Informel, i.e. non-representational pictures, there are no clues to the real world or geometric forms. The 'How' and 'Where' comes from your imagination; you think up a composition, design spaces and forms, choose colours, and determine textures. This challenging, developmental work is guided by intuition, the power of your imagination, and the ability to express yourself.

- Refrain from any spatial or naturalistic models.
- Concentrate on the colour relationships and the effects of surfaces, which lead directly back to the qualities of the selected materials.
- Apply dashes of paint without any rational control.
- Start working from motion, combining line, form, colour, and texture and react to the situations that arise.
- Represent your feelings and sensations, and spontaneously improvise upon your ideas to transform these into pictures.

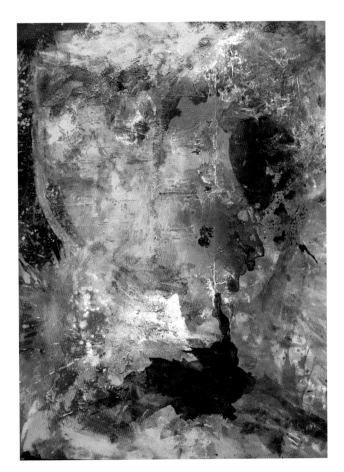

Ways of working

Every abstract picture is an arrangement of primary and secondary pictorial elements. The more you let yourself go, the more confident you will become in your sense of how to use these sources freely and intuitively.

Find your way with the primary pictorial elements:

colour, space, form, line, texture

The secondary elements will help you with the execution:

- **Motion** is the visible movement from one place to another, and brings life to the picture. The eye is actively guided across the picture's surface and even beyond it.

- **Dynamics** A dynamic application of paint looks vivid; a picture with the same constant brushstrokes, for example, is boring.

- **Direction of application** Horizontal elements suggest rest, diagonal or vertical elements suggest dynamism.

- **Rhythm** Matching, rhythmic repetitions of primary pictorial elements connect the individual areas of the picture because our eyes follow the rhythm.

- **Repetition** A selected colour shade should be applied several times, and should, for example, provide the diagonal connectivity of the picture.

- **Variation** A picture needs more than the same forms and colours all the time; even little variations or gradations can help.

- **Pattern** Repeating existing patterns with the same shape creates connecting highlights.

- **Focus** The clear positioning of a main element draws the viewer in.

- **Contrast** A clear differentiation of tonal values draws attention and brings tension to the picture.

- **Opposition** Within contrasts such as light and dark, you have the possibility of playing with form and space.

- **Harmony** Despite all the opposition, a certain harmony should be noticed within the picture.

- **Dominance** The different weighting of spaces creates tense pictorial statements. A large space, for example, requires several small spaces as a counterweight.

- **Balance** requires an evenness in the composition, almost a visual equalizing of the primary elements of the picture.

LESSONS AND EXERCISES

With the help of the following lessons, you will get to know your 'building blocks of possibility'. To begin with, the contents of the lessons cover the generally valid, theoretical aspects of the rules of pictorial composition and the technical aspects of texture and collage. With regard to abstract painting, the exercises on the primary pictorial elements of paint, space, line and form, combined with the secondary elements, create the essence of this book. At the end of every lesson, you will find the corresponding exercises, which are designed to strengthen and internalize your artistic capabilities. Invest your time in as many practice exercises as possible and gather as much experience as you can of using materials and techniques. By consciously working with the building bricks of an artwork, you will strengthen your intuition. This will make it easier for you to find ideas and to develop an individual, expressive, and original way of working. Approach the exercises in a playful way and without any pretentions. The result does not have to be a 'beautiful picture'. Enjoy what you do on these fascinating voyages of discovery, and broaden your sense for colour and composition 'along the way'.

- The order of the lessons is arbitrary and is not structured in increasing levels of difficulty.
- Some exercises are easy to do in a short space of time, while others are difficult and will keep you occupied for several days or even weeks.
- Each of the described layers basically needs to dry out before you start on the next layer. Only in exceptional cases (explicitly mentioned in the working steps) will you work into paint that is already wet or damp.
- The exercises are based on a specific focal point and refer to the content of each lesson. Aspects from other lessons are also used and mixed in, as they cannot be left aside.
- Do not just try to 'repaint'. The illustrations serve more as inspiration and should help you to visualize the exercise.
- Always leave room for spontaneity and intuition. Consider the example only as a stimulus and not as the measure of all things.
- I strongly advise you to repeat the exercises several times and experiment with the instructions to internalize the step sequences.

The concept of each exercise can be seen at a glance:

- Title of the exercise
- Thematic focus, primary and secondary pictorial elements
- Tools/materials
- Working steps – structured presentation of the step sequences
- Tip – Variations

Normally, all of the techniques are combined. Using two or more painting techniques will open up new possibilities of working and perceptions. In mixed-media terms, paint applications of varying consistencies overlap with collage and textural elements. Let yourself get carried away and just do whatever comes into your mind.

UNDERPAINTING

The phrase 'fear of the blank canvas' describes the difficulty of starting a picture. With a painted base as a foundation, approaching the painting support medium becomes easier. This underpainting, as it is known, has no claims to be correct or more pleasant; it can be painted or pasted over at any time. Reduce your pressure to perform by first applying a carefree layer of paint or texture. Normally, neutral, moderate shades like a soft brown, ochre or grey are used. Green and blue make the work colder, while yellow, red and orange lend it warmth. Some artists prefer to use a colour that contrasts with the subject and deliberately leave some areas uncovered later. Others prefer dark colours to enhance the contrast between brightly lit objects and the dark background.

Stimuli

- Apply the paint leftovers on your palette onto a painting support. As well as being good for the environment (the residues would otherwise end up in the bin), it creates random colour arrangements.
- Use old or unloved colours for the underpainting; this leads to exciting colour combinations that you would never consciously choose.
- Generously and spontaneously applied brushstrokes result in an interesting surface texture.

MATERIALS

The most beautiful subject cannot be done justice to if the materials used are of inferior quality. For that reason, use high-quality materials so that you can concentrate fully and completely on what is essential: painting.

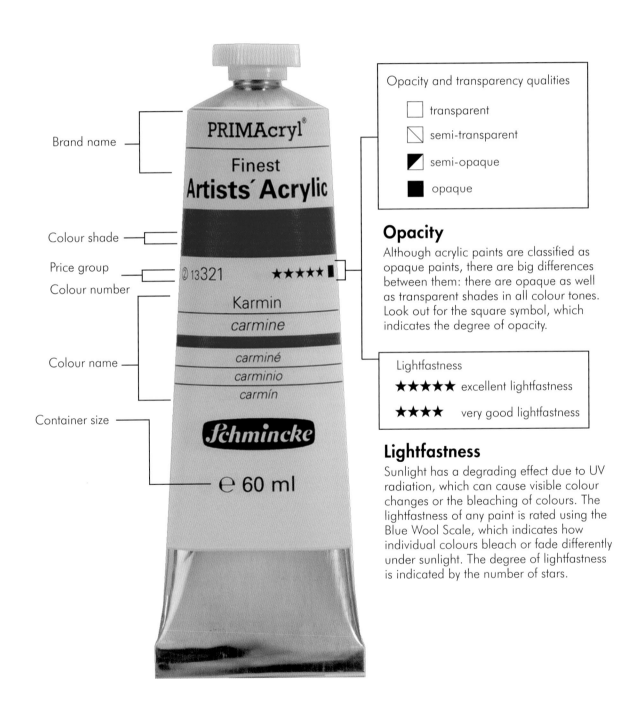

Brand name

Colour shade

Price group

Colour number

Colour name

Container size

PRIMAcryl®

Finest
Artists´ Acrylic

2 13321 ★★★★★ ◪

Karmin

carmine

carminé
carminio
carmín

Schmincke

e 60 ml

Opacity and transparency qualities

☐ transparent

◻ semi-transparent

◪ semi-opaque

■ opaque

Opacity

Although acrylic paints are classified as opaque paints, there are big differences between them: there are opaque as well as transparent shades in all colour tones. Look out for the square symbol, which indicates the degree of opacity.

Lightfastness

★★★★★ excellent lightfastness

★★★★ very good lightfastness

Lightfastness

Sunlight has a degrading effect due to UV radiation, which can cause visible colour changes or the bleaching of colours. The lightfastness of any paint is rated using the Blue Wool Scale, which indicates how individual colours bleach or fade differently under sunlight. The degree of lightfastness is indicated by the number of stars.

PAINTS

You can find information about the quality of the product and the specific properties of the individual shades of a range on the label of the packaging.

- Acrylic paints are generally pastose. Paints with the 'Heavy Body' additive, which retain a stable structure once dried and do not 'collapse in', are excellently suited to spatula techniques.
- High-quality paints are available as liquids which, with the highest pigment concentration, have a soft-flowing consistency.
- Highly pigmented liquid acrylic paints are sold in little bottles, with a pipette to remove the paint. They are suitable for glazing, for wet-in-wet technique, and for drawing with reed or steel-nib pens.
- Ink dries similarly to water-soluble watercolour paint, but has poor lightfastness.
- Indian Ink is similar to ink; additional binding agents make it waterproof, lightfast, and sometimes even indelible.
- Water-resistant oil pastels provide special effects under diluted, applied acrylic paint or in final granulating applications.
- Soft pastels consist of 'pressed pigment dust in a mould', without the significant addition of natural binding agents.
- Soft pencils, thick graphite sticks, and coloured pencils are suitable for sketching or drawing linear traces.
- Natural charcoal sticks are good both for sketching and for drawing in accents in damp and dry colour spaces.
- Acrylic binder can be used for gluing collage material.
- With spray fixative you can permanently fix dry materials such as charcoal, pastel and pigment.
- Use varnish to protect your painted and dried pictures from dust and UV radiation.

PASTES AND GELS

Art supply shops stock different pastes and gels whose texture dries out without any loss of volume. Pastes dry opaque. Gels appear milky-white when wet; only during the drying process do they become transparent. A light texture paste or modelling paste are suitable as basic pastes – both are suitable for adding fillers which change the texture and for creating collages. Light texture paste is also very absorbent and good for glazing and for wet-in-wet technique. In addition to the basic pastes, there are numerous different products to which the manufacturers have already added effective fillers, such as pumice stone.

PAINTING SURFACES

- **Acrylic paper** should never weigh less than 350gsm, in order to be able to handle the impasto and multiple layers of paint. High-quality blocks are glued all the way round, in order to prevent an uncontrolled swelling and 'wave formation' when the paper becomes wet. The sheet is removed from the block only after the picture has completely dried.

- **Canvasses**: specialist shops stock primed canvasses which are stretched over stretcher bars and are ready to use. On unprimed canvas, you can determine the surface texture of the base coat yourself by, for instance, creating traces with a coarse bristle brush.
- **Canvas board** is made from primed canvas mounted on a stable greyboard. With a minimum thickness of 3–5mm (⅛–¼in), it is suitable for framing in conventional picture frames.
- **Alternative painting surfaces** include metal sheets, glass or plexiglass. Solid wood and the various types of pressboard from a builder's merchant should first be primed. Two layers of colourless, white or black acrylic primer is applied with a wide brush.

TOOLS

All techniques are possible with a selection of synthetic and bristle brushes of different widths. The following are recommended: a wide block brush for large areas of paint application and glazing, a cat's tongue brush for smaller colour spaces, and a thin round brush with a fine tip for details and lines.

- **Painting knives** are suitable for pastose, spatula techniques, as well as for the mixing of textural materials and the working of collage elements. For larger applications of paint, you can buy squeegees, flexible filling knives, or grouters from a builder's merchant.
- Synthetic **sponge rollers** and lambswool rollers provide for different paint textures.
- **Household sponges** are suitable for blurring soft colour gradations or to spread paint generously over a large format. You can dab paint textures on with a natural sponge.
- **Dried paint** can be sanded off or underlying layers partially exposed again with emery paper or pan scourers made from coarse metal threads.
- **With a spray bottle**, you can spray diluted paints onto the painting support medium in fine graduations.
- **Masking tape** can be used for masking sharp edges.
- **Tear-off palettes** made from paper with a coated surface can be disposed of in the ordinary waste. Pots are ideal for larger quantities of paint or glaze mixtures.

TEXTURE

Undulations, roughness, tactility and engraving – that is, any kind of effect which disrupts the smooth painting surface – is called texture. In addition to the application method and the manual working of texture pastes, this lesson also deals with the addition of texture-changing fillers. Visual, non-tactile textures such as graphite drawings or sprayed patterns are dealt with in the corresponding lessons.

MANUALLY DESIGNING THE SURFACE

Textures can be created in different phases of the painting process.

- **Before** – on the untreated painting surface
- **Between** – on dried layers of paint
- **After** – on the finished work

Use different tools and push your dexterity to the limit to manipulate the surface. Place so-called 'traces of motion' in the paste to bring movement into the picture.

Press lace edging or mesh into the paste, draw a spatula over it lightly, and the pattern will remain.

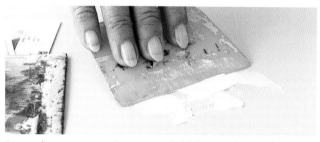

For applications over a large area, hold the spatula at a flat angle to the painting support and draw it across the space with a light pressure.

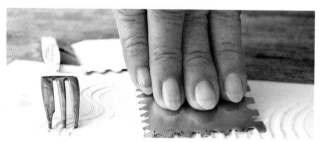

Evenly spaced lines can be easily engraved with an old fork, comb or notched trowel.

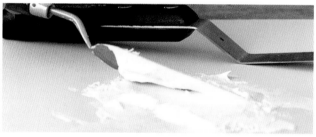

For thicker accumulations, take up the paste in small quantities and spread it in all directions, sometimes pressing down strongly, sometimes lightly.

Fine engravings are created with toothpicks and similarly pointed objects; if you want to create wider lines, you can use a bamboo reed pen.

You can use an old brush or a bristle brush to give the applied paste a groove-like texture or stippled effect.

You can create tactile forms by laying a stencil on top and then drawing texture paste over it with a spatula.

ADDITIVES AND FILLERS

You can change the consistency or the superficial effect of pastes by adding texture-changing fillers. You will be amazed at how many additives can be found in everyday items. You can even use organic materials such as sawdust or 'eco-waste', for example coffee grounds; however, it is important that they have completely dried out.

- **Ash** offers a wide range of grain sizes, from the finest dust to small pieces of charcoal. Even the coloration varies: depending on the type of wood burnt, it will produce light ochre shades, reddish hues, or even cold grey shades.
- **Coffee powder** as well as finely ground **black** or **green tea** not only provide interesting textures but also their own colour.
- Use **paving sand** available from a builder's merchant or **bird sand** for coarser and sandy-looking surfaces.
- **Dried spices**, **seeds**, and **grains** offer an immense variety of shapes.
- Scattered **sawdust** will become caked or will remain powdery depending on the dampness of the applied texture.
- **Wood shavings** produce interesting coarse textures.

PRACTICE

As if you were making cookie dough and blending flour, nuts and other ingredients, mix granular or powdered additives into pure paste. Pay attention to the proportions of paste to additives. The mixture must not become too dry, otherwise it will not be sufficiently adhesive to bind permanently to the painting support medium.

- Take care not to overwhelm the adhesive strength of the acrylic binder – paste that has been blended with additives should not 'crumble' when it is damp.
- Create uniform mixtures in advance on the pallet or in a pot.
- For vibrant mixtures of varying intensity, mix the additive on the painting support medium only when applying the texture.
- Powdered additives absorb the liquid of the acrylic binder quickly. This means that these textures also dry quickly.
- You can colour pastes and gels with pigments or with pastose or liquid acrylic paint.
- Pastes contain white components, in contrast to the clear gels. If you add colour to paste, the pure colour effect is reduced and you obtain pastel shades.
- By mixing with transparent gel, the purity of the added colour is maintained.
- Sand with different colours and granulations is just as suitable as paving sand.

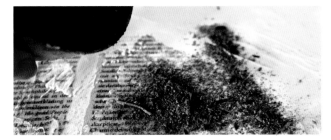

Ash is strewn onto the damp paste and is spread out unevenly with free movements.

By mixing with transparent gel, the purity of the added colour is maintained.

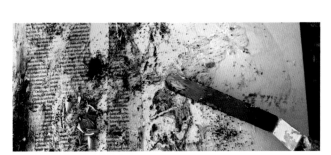

In addition, pencil shavings and coffee powder are worked in to link up the areas of texture.

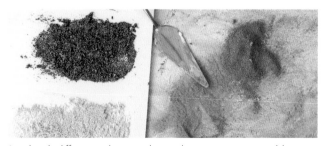

Sand with different colours and granulations is just as suitable as paving sand.

TECHNIQUES FOR APPLYING COLOUR ON A DRY TEXTURE

The glazing process and the dry brush technique are suitable for painting textured surfaces. An application of pastose opaque paint would only close up the nicks and recesses in the applied texture, thereby neutralizing their effect.

- Liquid glazes cannot adhere to the elevated areas of the texture because they flow off and collect in the recesses. This enhances the effect of depth in an effective way and emphasizes the contrasts of the applied layers.

- You can increase the colour run-off of the applied glaze paint by spraying water on afterwards.

- Glazing flows into the recesses (as it has in this net texture, for example and dries in the grooves more intensely than it does in the elevated areas.

- The dry-brush technique works best if you brush over the rough texture with a frayed bristle brush without applying any pressure.

- Allow these types of paint applications to dry in a horizontal position. Do not use the paintbrush on a coat of paint that is drying; this is more likely to destroy than to improve.

- You may want to tilt your image back and forth to allow the wet paint to flow into the desired depressions or specific areas.

- Accept the inherent dynamics of the materials and allow uncontrolled outcomes.

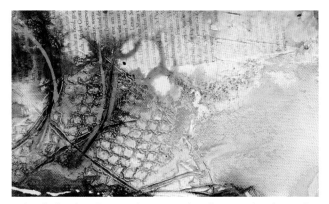

In the dry-brush technique, the paint only adheres to the elevated areas and accentuates the textural application in reverse.

Applying granulating soft pastel highlights textures, such as the jagged traces of movement seen here.

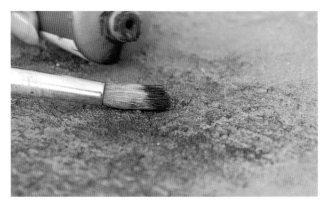

Oil pastels or soft pastels are also suitable for granulated applications of colour.

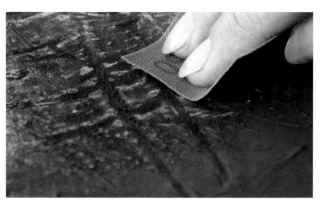

To set some highlights or bring out the underlying colour, rub the elevated areas with sandpaper.

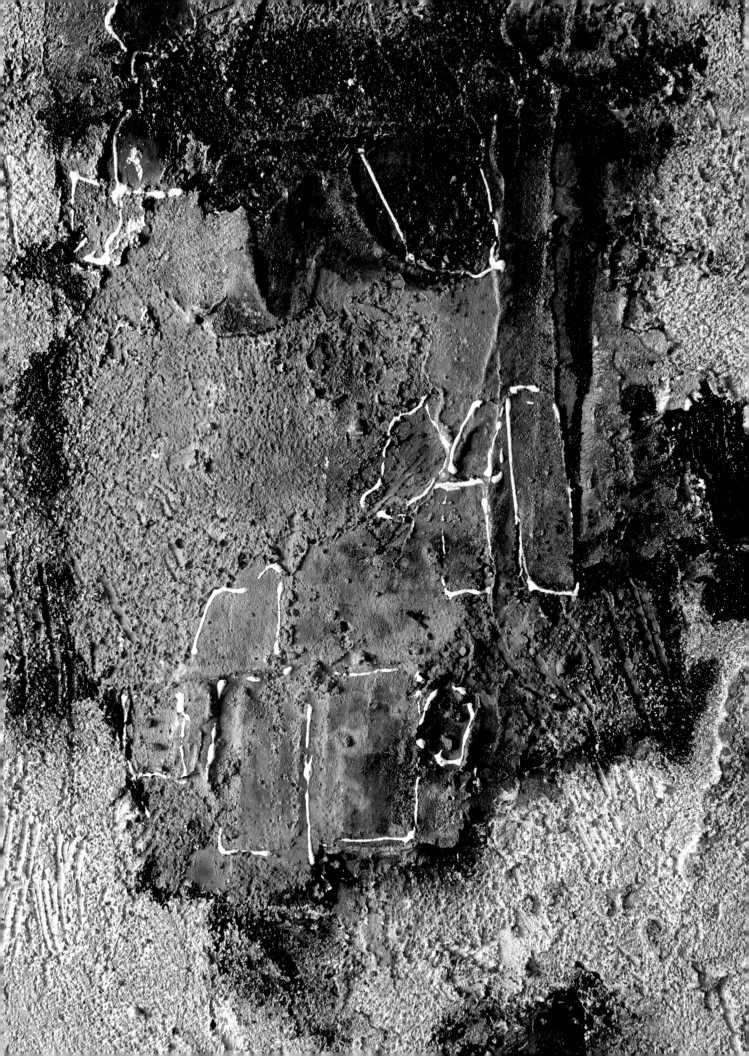

Glaze on a Coarse, Sandy Texture

TASK AND MATERIALS

Focal points

Colour, space, line, texture, variation, dynamics, contrast, painting surface

Equipment

Spatula, flat brush, dosing bottle, spray bottle

Materials

Stretched canvas 40 x 60cm (15¾ x 23½in), light texture paste, silica sand

Acrylic paints: Titanium White, Sand, Warm Grey, Primary Cyan

Pigments: Cobalt Blue, Moorlauge

Original format

PRACTICE

Mix the paste with the silica sand and apply the mixture using a spatula in generous motions across the greater part of the painting surface. You can leave any spontaneously occurring gaps in the texture you apply free, in order to maintain a view of the blank canvas. For a second layer, apply pure paste to the central area of the image and around the edges of this application, to create some sharp, tactile nicks. Using a slightly diluted Warm Grey, glaze over the entire space with the flat brush; repeat this process with Sand. Using the dosing bottle, fill the gaps in the texture with Moorlauge and spray the edges with water. In the still-wet application, pour some slightly diluted Cyan into the central area of the picture and dust some Cobalt Blue pigment over it. Finally, using a thin nozzle on the dosing bottle, outline some of the sharp textures with slightly diluted Titanium White.

TIP

Moorlauge behaves differently to acrylic paint; it is more efflorescent and is water-soluble when dry.

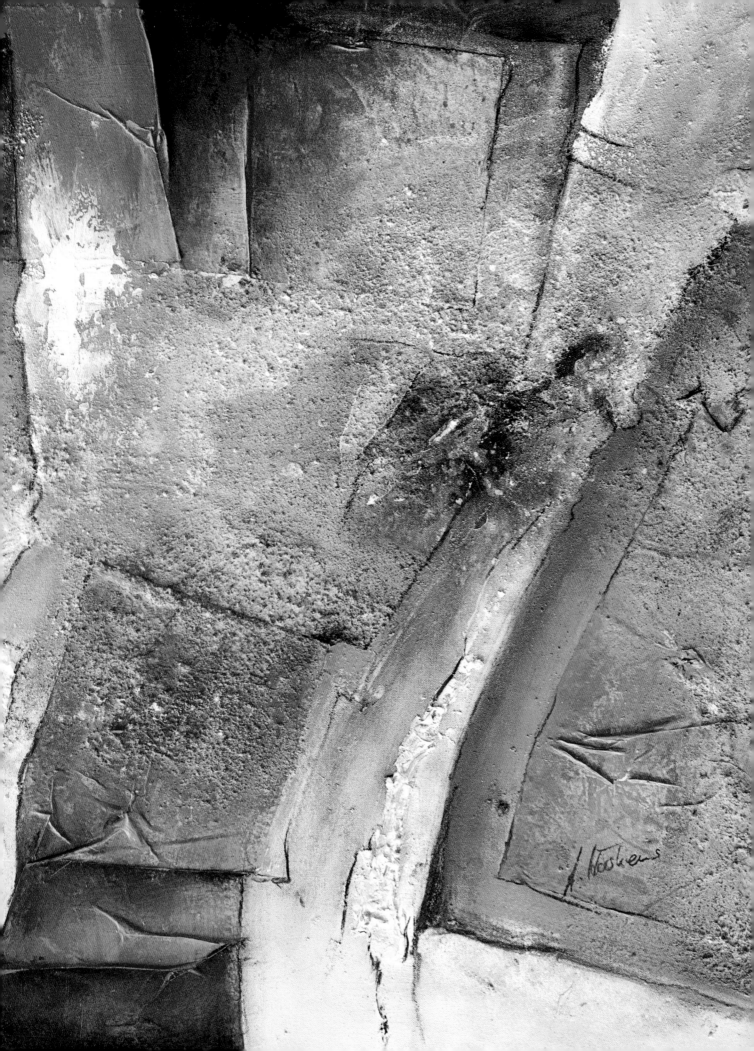

Texture on Paper Collage

TASK AND MATERIALS

Focal points

Colour, space, line, texture, variation, dynamics, motion, contrast

Equipment

Spatula, flat brush, spray bottle

Materials

Stretched canvas 80 x 120cm (31½ x 47¼in), light texture paste, silica sand, ash, acrylic binder, packaging paper, tissue paper, charcoal

Acrylic paints: Titanium White, Indian Yellow, Burnt Sienna, Black

Original format

INSTRUCTIONS

Use the paste to attach some crumpled tissue paper to a few separate areas of a collage of wide, pleated strips of packaging paper. Using the spatula, spread paste mixed with silica sand across the paper collage, as well as onto the blank canvas. Work Burnt Sienna and Indian Yellow into some areas of the surface using the flat brush. Link up the daubs of paint in Titanium White and Black. Mix some acrylic binder into some slightly diluted Titanium White, and pour it over large areas. Then, with full force, throw some ash into the damp paint. Where required, use the spatula and some Titanium White to add in a few light spots. A final outlining of the spaces with charcoal separates the individual areas from each other and reinforces the picture's expression.

TIP

Due to light refraction, the dusty ash thrown onto the surface gives the underlying colours an extraordinary radiance.

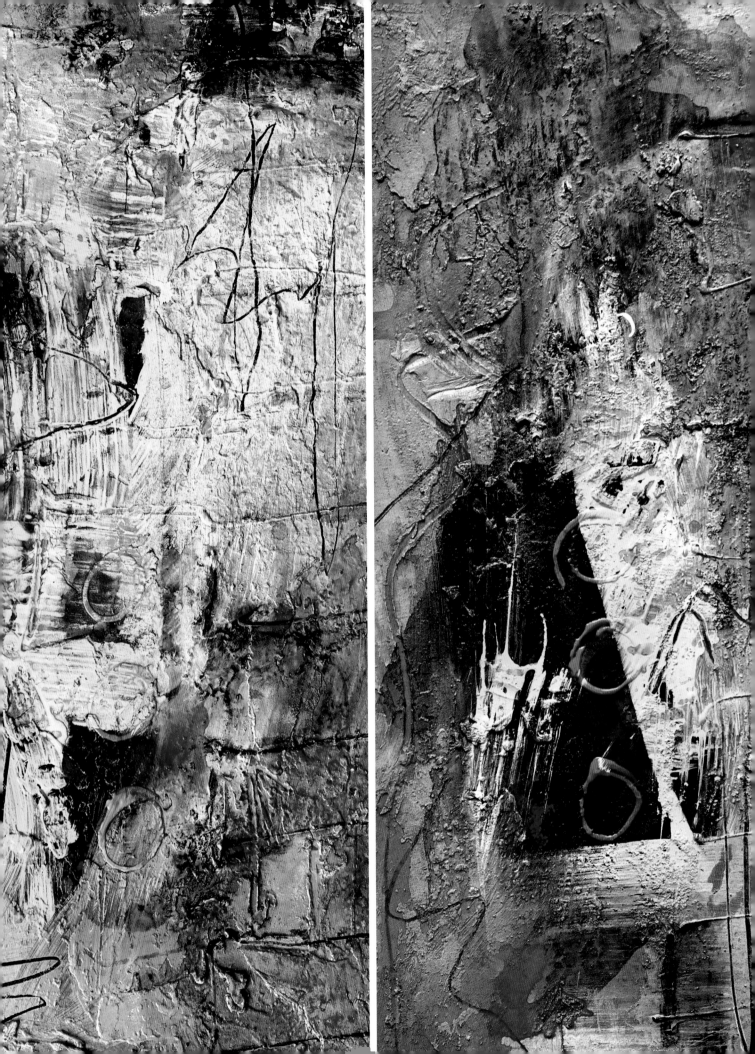

Tactile and Engraved Lines on Texture

TASK AND MATERIALS

Focal points

Colour, space, line, texture, variation, dynamics, motion, contrast

Equipment

Graphite stick, spatula, flat brush, dosing bottle, pencil

Materials

2 stretched canvasses 30 x 70cm (11¼ x 27½in), light texture paste, silica sand, wood shavings

Acrylic paints: Titanium White, Flesh Tint, Transparent Orange, Black

Original format

INSTRUCTIONS

Using the spatula, apply paste freely and mix in some wood shavings and silica sand. Scribble some lines into the wet texture application using a thick graphite stick. Take an opaque underpainting in Flesh and begin by pouring a Black glaze onto the central area of the picture. Pour a very diluted Transparent Orange over the entire surface of the picture, and use the brush to swipe out the paint residues over it. Fill a dosing bottle with slightly diluted Black and, using a thin nozzle, draw a border of rectangles along one of the vertical edges extending about a third of the way in; do the same with the Orange and position three round loops vertically. Use undiluted Titanium White on the flat brush and apply it in vertical/ horizontal passes. This leaves clear brushstrokes behind. Dilute the residual paint in the brush and swipe this across the picture. Scribble some lines into the wet paint using the pencil. Finally, pour, splatter and spray a final coat of Orange over large parts of the space.

TIP

Eventually, the sequencing of the various layers is no longer discernible. Where layers are partially or completely overlaid, often only a small area of the lower layers remains visible.

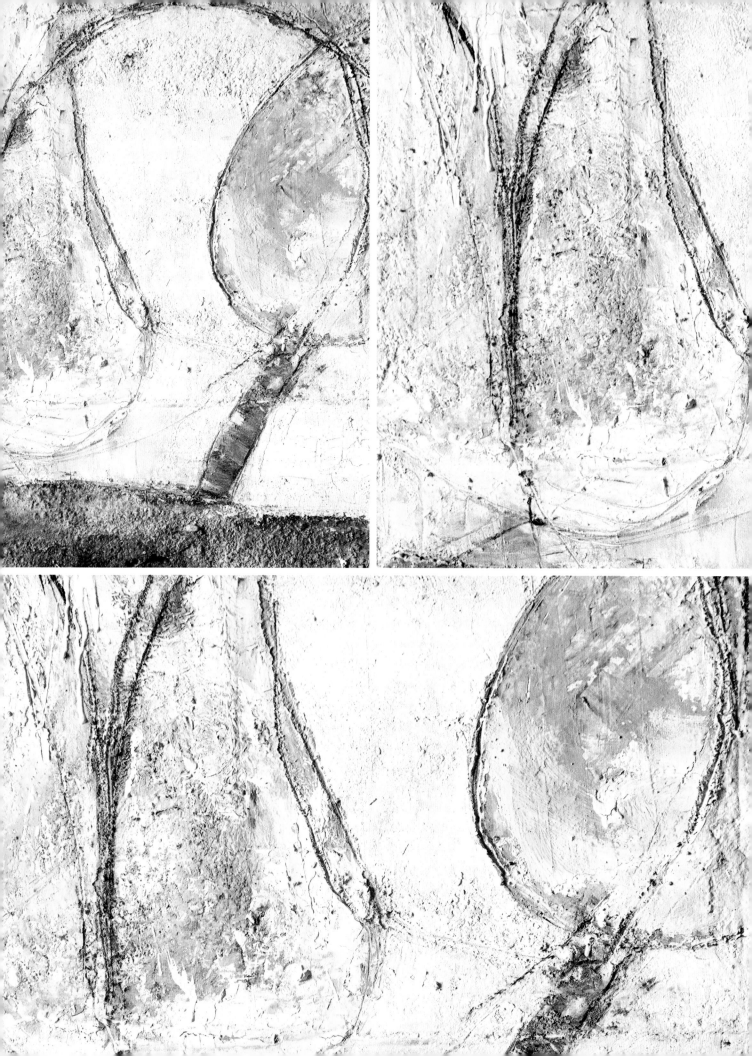

Engraving on Texture

TASK AND MATERIALS

Focal points

Colour, space, line, texture, variation, dynamics, motion, contrast

Equipment

Spatula, flat brush, spray bottle

Materials

3 stretched canvasses: two 60 x 80cm (23½ x 31½in), one 20 x 80cm (7¾ x 31½in), light texture paste

Marble powder, ash, wood shavings, acrylic binder

Acrylic paints: Titanium White, Primary Yellow, Orange, Warm Grey

TIP

With the exception of the undercoating, the individual layers were worked in one go, without any drying time between them.

Original format

INSTRUCTIONS

Apply an impasto underpainting in Orange using the flat brush. Apply Warm Grey in generous patches using the spatula and spray the edges of the paint with water. Mix marble powder, paste, ash and wood shavings into a thick mash, and add about a third of this amount of acrylic binder again to the mixture. Apply the mass relatively thickly with the spatula to the desired areas. For the remaining spaces, mix equal amounts of marble powder and acrylic binder and use the spatula to apply this mass in generous, sweeping oval strokes. Squeeze the Yellow directly out of the tube in sweeping lines across the canvas, drag the paint, and scrape and scratch into the wet texture with a spatula. Pour some slightly diluted Titanium White across some areas of the picture, and throw some marble powder into the wet paint, at full force. Finally, use the back of the brush to engrave outlines into the damp upper surface, and define the forms resulting from the working process. The colour of the undercoat appears in the engraved tracks.

Developed as a triptych, the dynamics extend across three canvasses.

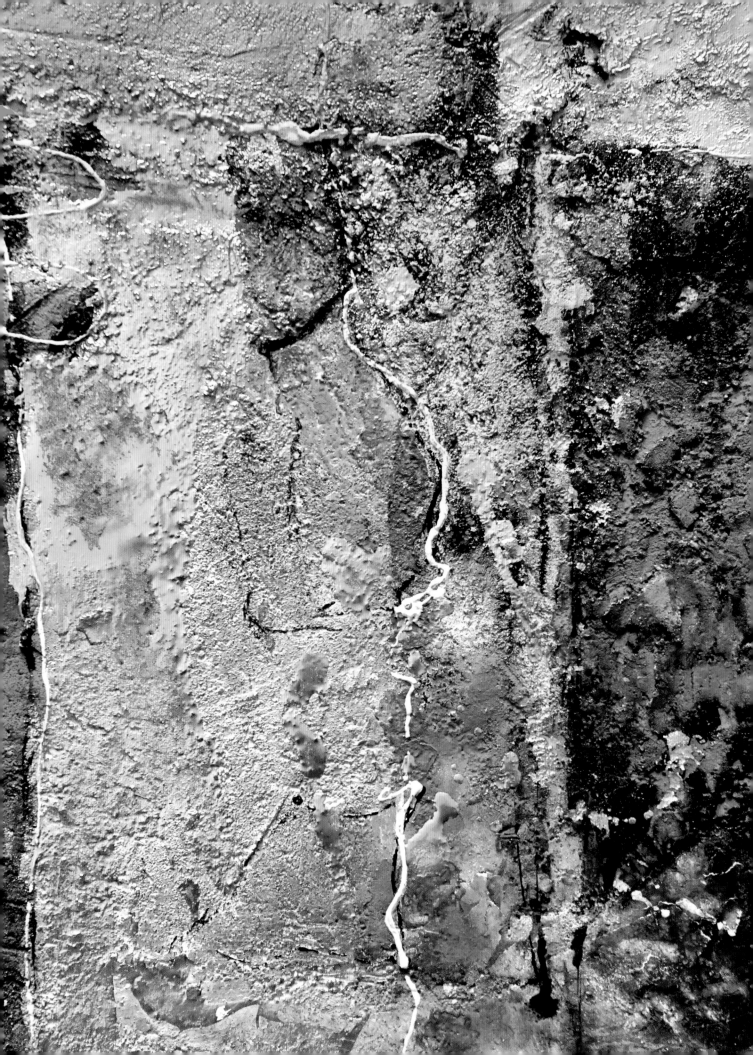

Bronze Gilding on Texture

TASK AND MATERIALS

Focal points

Colour, space, line, texture, variation, dynamics, motion, contrast

Equipment

Spatula, flat brush, spray bottle, dosing bottle

Materials

Stretched canvas: 40 x 40cm (15¾ x 15¾in), light texture paste, silica sand, marble powder, acrylic binder, Moorlauge

Acrylic paints: May Green, Primary Cyan, Pebble Grey, Titanium White

Acrylic bronze: Rich Gold

Original format

INSTRUCTIONS

Mix the paste with the silica sand, and, using a spatula, apply the mixture in generous motions over the greater part of the painting surface, which has been underpainted in May Green. You can leave any spontaneously occurring gaps in the texture application free, in order to maintain a view of the blank canvas. For the smoother second application, mix marble powder and acrylic binder in a 3:1 ratio and draw it across the rough, sandy texture in the desired areas. Using the dosing bottle, fill in the textured gaps with moorlauge and spray the edges with water using the spray bottle. In the still-wet application, pour slightly diluted Cyan into the central area of the picture and splatter some May Green into the damp paint. Glaze the picture with one wide block strip of diluted Pebble Grey, and swipe out the paint residues with the brush. Using a thin nozzle on the dosing bottle, outline some of the sharp textures with slightly diluted Titanium White. Dilute acrylic bronze slightly with binder in a bowl and pour it around the area of the left vertical third line, over the glazed space. Then, granulate out the paint residues in some places with the flat brush.

TIP

The poured bronze gilding stands in complete contrast to the coarse textural application and creates great effects through its smooth, glossy surface.

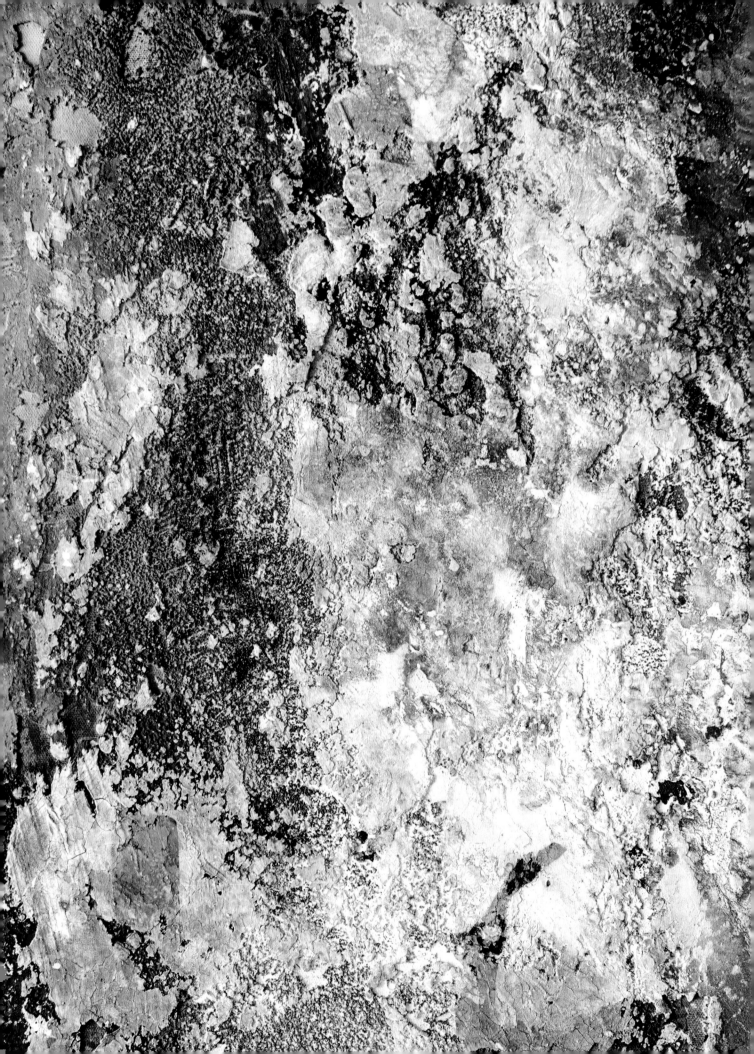

Multi-layers of Texture

TASK AND MATERIALS

Focal points

Colour, space, texture, variation, dynamics, contrast

Equipment

Spatula, flat brush, spray bottle

Materials

Stretched canvas: 40 x 60cm (15¾ x 23½in), light texture paste, silica sand, wood shavings, marble powder, acrylic binder

Acrylic paints: Titanium White, Warm Grey, Golden Ochre, Ultramarine Blue, Vandyke Brown

Original format

INSTRUCTIONS

Mix the paste with the silica sand and, using a spatula, apply the mixture in generous movements across the greater part of the painting surface. You can leave any spontaneously occurring gaps in the texture application free, in order to give glimpses of the blank canvas.

Using the flat brush, glaze over the entire space with a slightly diluted Warm Grey; use enough paint to allow colour puddles to form in the depressions.

For a second layer, apply paste with some wood shavings to the central area of the image. Pour some very diluted Vandyke Brown generously over the entire space, and spray the edges of the paint with water. Starting from the side edges of the picture, glaze some slightly diluted Golden Ochre inwards and splatter some diluted Ultramarine into the wet paint. For the final smoothing textural application, mix marble powder and acrylic binder in a 3:1 ratio and cover over the coarse, sandy texture in the desired areas, leaving some sharp nicks. Finally, pour on diluted Titanium White and spray the edges with water.

TIP

A layer poured onto textures should always be laid flat and left to dry overnight before applying the next layer. This can even take several days for thickly textured layers.

COLLAGE

A collage (French: coller = to stick) comes about through the attachment of various materials to the painting support medium. Max Ernst once defined collage as 'the systematic exploitation of the accidentally or artificially provoked encounter of two or more foreign realities on a seemingly incongruous level – and the spark of poetry that leaps across the gap as these two realities are brought together'. Georges Braque and Pablo Picasso introduced collage into modern art in about 1910.

PRACTICE

First, arrange your elements on the painting support medium. Try different compositions; tear your material into different shapes if necessary. Only stick the elements on when the composition appears harmonious. For thin and flexible materials, use acrylic binder; for voluminous and rigid materials, texture paste is better. Avoid 'air bubbles'. Stroke the material firmly with the painting knife from the inside out, and, in doing so, squeeze out excess adhesive to the side.

- Tissue paper or very thick packaging paper (e.g. wrapping paper from shoe boxes) can be folded wonderfully well into fine wrinkles.
- You can also insert crumpled or thicker folded paper into the spaces between the folds.

Partially stuck-down collage materials should never be immediately visible in the finished image, and should therefore be integrated as well as possible. To prevent the picture looking like a piece of handicraft, combine the elements into a single entity with the subsequent application of texture or paint.

- Individual pieces of paper fit harmoniously into the picture if you tear the edges instead of cutting them.
- Use texture paste to seamlessly join the elements to the painting support medium.
- Apply the colours in the collage elements to the surrounding space.
- Connect the transitions with printed patterns or linear textures.

Paper is available in a multitude of colours, surfaces and textures.

First apply a thin layer of acrylic binder onto the painting support.

Press the paper in the desired texture onto this adhesive.

Press out the air bubbles and excess adhesive to the side, using the spatula.

Apply some paste to the edges of the paper in order to hold it in place and to integrate the object seamlessly into the rest of the picture's surface.

STIMULI

Collage elements that are detached from the subject are always attractive. Create a stock of various thin Chinese papers. When glued transparently with binder to underlying paint applications, it produces magical effects.

- **Frottage** – with a soft graphite stick or an oil pastel, you can take rubbings of a pattern, a stencil or string.

- **Paint traces** – use a flat paintbrush to paint opaque colour spaces, such as stripes, or outlined forms, such as an oval.
- **Colour traces** – draw a spontaneous tangle of thick and thin lines with oil pastels.
- **Shapes** – cut out shapes using scissors or a circle cutter; you can also use the shadow mask, which falls away.

Frottage with graphite

Hand-cut stencils

Colour traces in acrylic paint

Negative stencil with a circle cutter

Colour traces in oil pastel

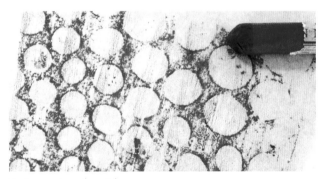

Frottage using oil pastel

PRACTICE

Arbitrarily tearing the paper elements allows you to abstract the imposed patterns. Arrange the fragments loosely on the painting support medium. Try out different compositions. After first spraying with a water bottle – to make the paper transparent – glue the elements down with diluted acrylic binder.

The use of string offers another possibility for collage. Arrange some twine or coloured strands of wool in straight lines and patterns on the painting support medium. Instead of attaching the threads in an elaborate way, paste some thin Chinese paper over them. This paper is malleable, and soft enough to mould to the tactile forms.

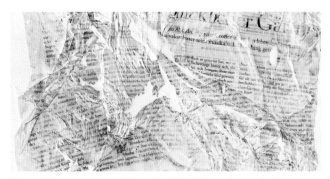

Crumpled newspaper collaged with binder and reworked with paste

Organize the string on a layer of acrylic binder

Crumpled tissue paper after multiple glazes

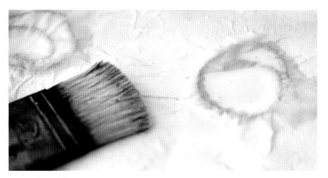

Paste thin Chinese paper over the string

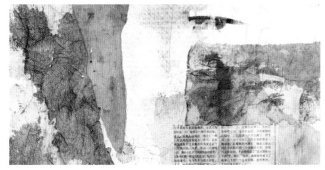

A mix of different papers

Press down firmly on the damp paper with the brush

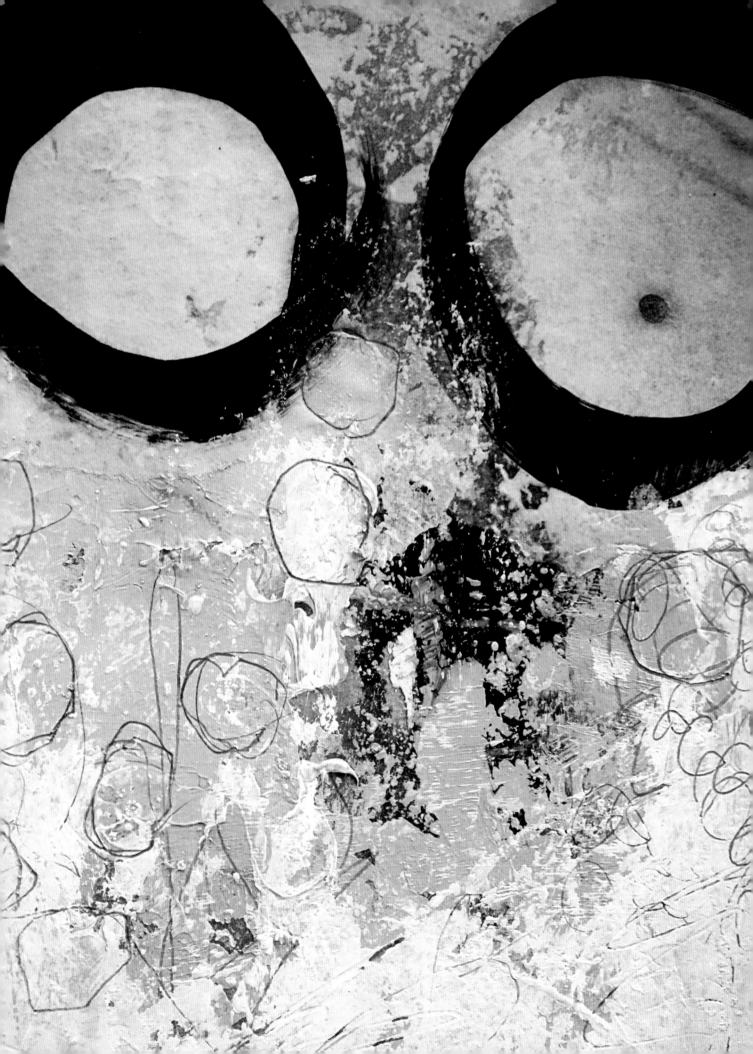

Chinese Paper on Paint Texture

TASK AND MATERIALS

Focal points

Colour, space, form, line, texture, harmony, dynamics, repetition, pattern

Equipment

Spatula, flat brush, pencil

Materials

Stretched canvas: 40 x 60cm (15¾ x 23½in), Chinese paper, acrylic binder

Acrylic paints: Titanium White, Royal Blue, Violet, Pebble Grey, Burnt Sienna, Vandyke Brown, Black

Original format

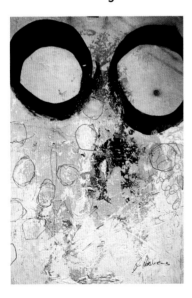

INSTRUCTIONS

Paint opaque black circles on Chinese paper and put this aside to dry. On a Vandyke Brown and Burnt Sienna underpainting, paint some spaces in Violet. Use a spatula to apply Royal Blue to the upper two-thirds of the picture and Pebble Grey to the bottom third. Work intuitively, and leave enough space free so that the layers underneath can be seen. Scribble some loose tracks and small circles into the wet paint with a pencil. Begin by arranging the collage and trying things out. Do not stick down the pieces with acrylic binder until you are happy with the composition. With the spatula, apply Titanium White from the bottom edge, granulating upwards and repeating the scribbling with the pencil.

TIP

The compact forms seem to float over the applied paint when collaged onto the transparent, drying Chinese paper.

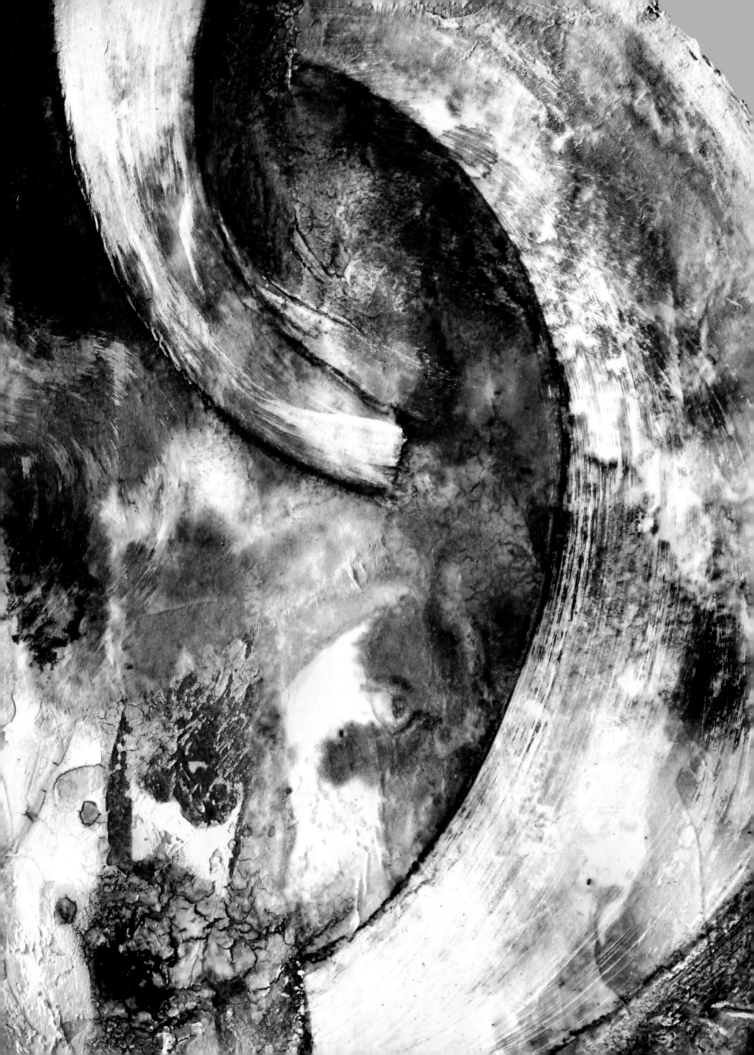

Collage on Crackle Paste

TASK AND MATERIALS

Focal points

Colour, space, form, texture, motion, dynamics, direction of application, balance

Equipment

Spatula, flat brush, spray bottle

Materials

Stretched canvas: 40 x 60cm (15¾ x 23½in), crackle paste, acrylic binder, charcoal, Chinese paper

Acrylic paints: Titanium White, Linden Green

Aero Color: Brown Brazil

Original format

INSTRUCTIONS

Use a flat brush to paint sweeping, oval brushstrokes in Titanium White onto Chinese paper, and put this to one side to dry. Use the spatula to apply crackle paste onto a Linden Green underpainting, in a loose form across the greater part of the picture surface, leaving part of the underpainting visible. Apply Brown Brazil to the upper edge of the picture. Place the painting support medium in a vertical position to let the paint run downwards; spray the rest with water. First, arrange the collage elements in order to try things out. Pay attention to the balance of the shapes, and stick down the pieces with acrylic binder. Emphasize the forms with a charcoal outline. Shade the background from the upper edge of the picture downwards, by rubbing some charcoal dust in with your fingers.

Interim stage before negative emphasizing

TIP

Collaged, opaque paint traces on Chinese paper float above the layer beneath.

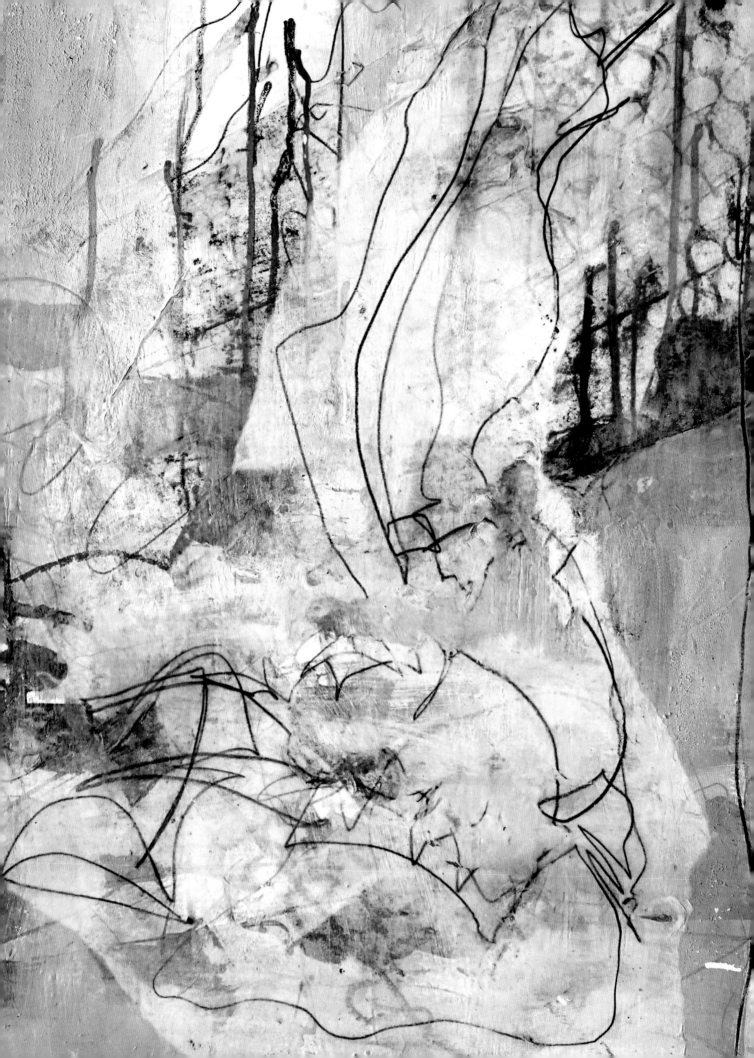

Glaze on Different Papers

TASK AND MATERIALS

Focal points

Colour, space, line, form, pattern, harmony, variation

Equipment

Flat brush

Materials

Stretched canvas: 60 x 80cm (31½ x 23½in), acrylic binder, a variety of paper including Chinese, 6B graphite stick

Oil pastel: Magenta

Acrylic paints: Sand, Black, Warm Grey

Original format

INSTRUCTIONS

Paint a row of various large shapes freely onto Chinese paper with undiluted Black acrylic paint, and let it all dry. On the same paper, with a magenta oil pastel, take rubbings of different surfaces, such as a perforated sheet. Tear up the collage. Begin by arranging the pieces, trying things out. Only when you are happy with the composition should you stick the pieces down. Scribble over the entire space with both the graphite stick and the oil pastel. Pour a slightly diluted Warm Grey over the central area of the picture, and place the painting support medium in a vertical position to let the paint run downwards. Next, paint wide block stripes in Sand with the flat brush.

On a large piece of Chinese paper, draw an abstract shape with the graphite and stick it down over at least two-thirds of the space. As it dries to partial transparency, the upper layer of paper veils the layers underneath.

Use this variation to work with the same materials and in analogous steps, but with minor alterations to each image.

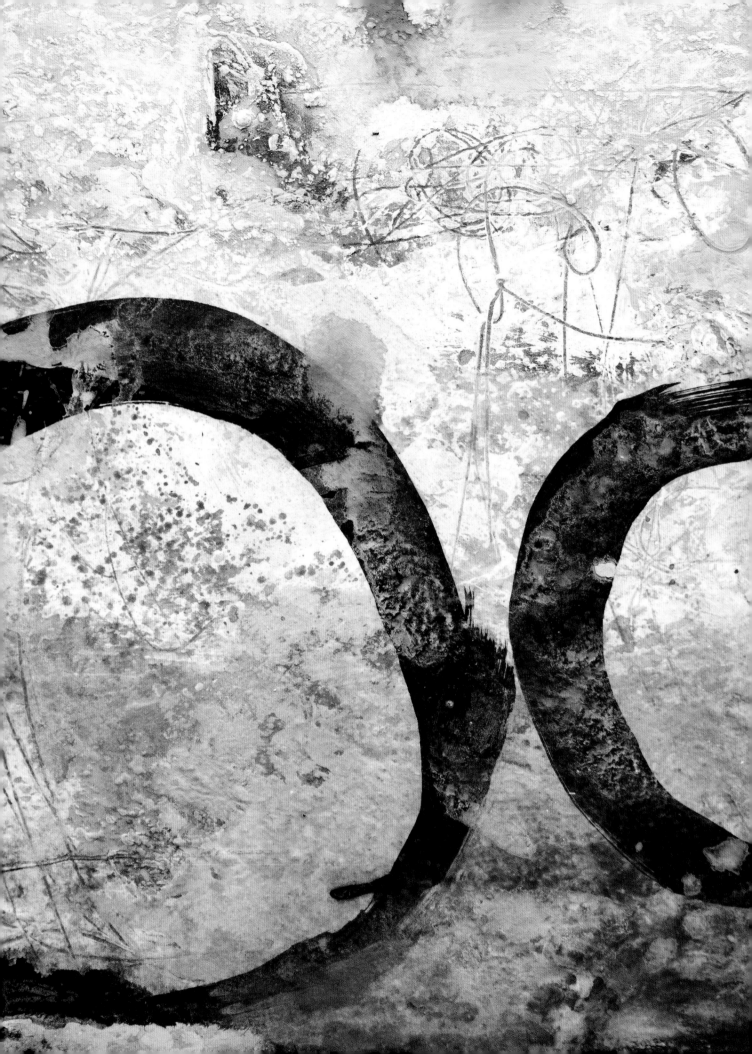

Chinese Paper on Layers of Colour

TASK AND MATERIALS

Focal points

Colour, space, line, form, dynamics, focus, harmony

Equipment

Spatula, flat brush, spray bottle, pencil

Materials

Stretched canvas: 60 x 80cm (23½ x 31½in), Chinese paper, acrylic binder

Acrylic paints: Titanium White, May Green, Hooker's Green, Cobalt Turquoise, Yellow Ochre, Vandyke Brown, Pebble Grey

Original format

INSTRUCTIONS

Paint opaque black circles on Chinese paper and put this aside to dry. Take a Yellow Ochre underpainting and use a spatula to apply some May Green and Hooker's Green in loose succession onto the painting support medium. Leave part of the underpainting visible. Use a spatula to apply Pebble Grey onto the left edge of the picture, granulating inwards. Swipe the diluted residues onto the picture with the flat brush. Use a pencil to engrave dynamic traces into the damp paint. Glaze the vertical left third with Vandyke Brown. Granulate over the remaining two-thirds of the picture surface with Titanium White. First, arrange the collage and try things out. Only when you are happy with the composition should you stick down the pieces with acrylic binder. With the flat brush, splatter a diluted mixture of White and Cobalt Turquoise over the entire space.

Interim stage before the collage

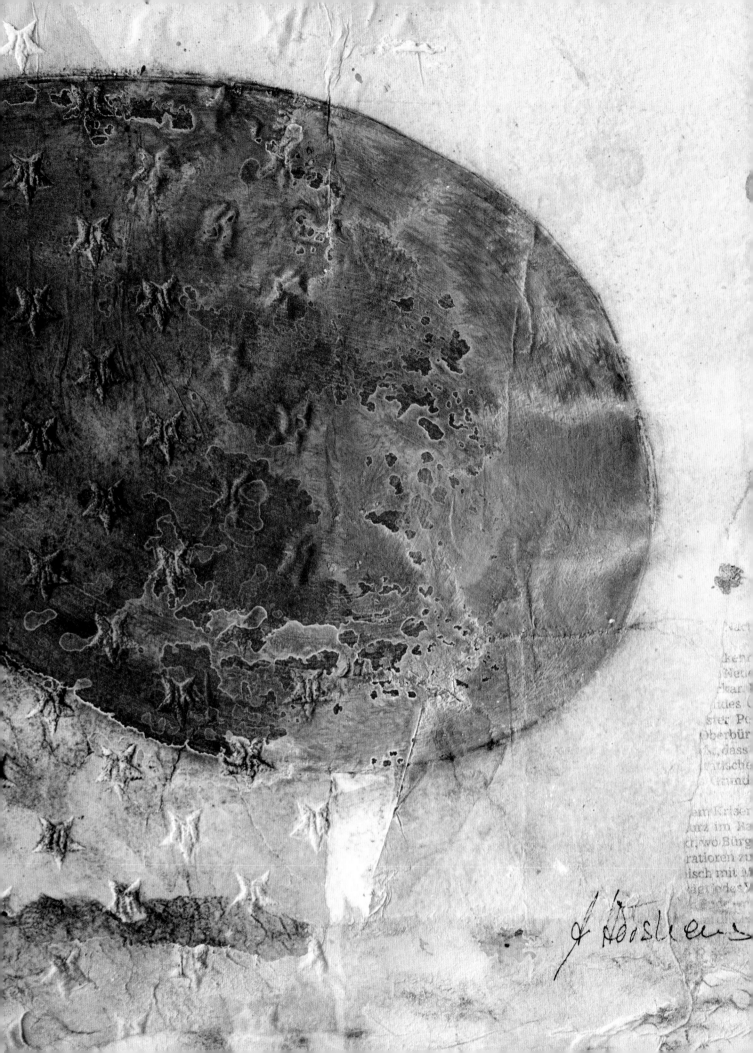

Glaze on Paper Collage

TASK AND MATERIALS

Focal points

Colour, space, form, pattern, balance, dominance

Equipment

Flat brush, spray bottle

Materials

Stretched canvas: 30 x 40cm (11¾ x 15¾in), charcoal, acrylic binder, a variety of papers (here: wrapping paper, newspaper, packaging paper, Chinese paper with frottage)

Acrylic paints: Cobalt Turquoise

Aero Color: Supra White

Original format

TIP

Collages are easier to make if you work with each material in sequence.

INSTRUCTIONS

Start with a collage of various papers, first arranging the collage and trying things out. Only when you are happy with the composition should you stick down the partially overlapping pieces with acrylic binder. Here, I have used some wrapping paper with a star pattern, a newspaper cut-out, some blotted packaging paper, and a scrap of Chinese paper with a frottage. Use undiluted Cobalt Turquoise to paint on a truncated, relatively large oval shape. Outline it subtly with charcoal. In order to bring out the texture of the paper, use your fingers to rub some charcoal dust over the coloured form (and possibly also over some of the remaining space). Combine the individual spaces with a glaze. To do this, work Supra White from the right and bottom edges of the picture inwards and spray the edges with water.

Variation with an intermediate step before applying the paint

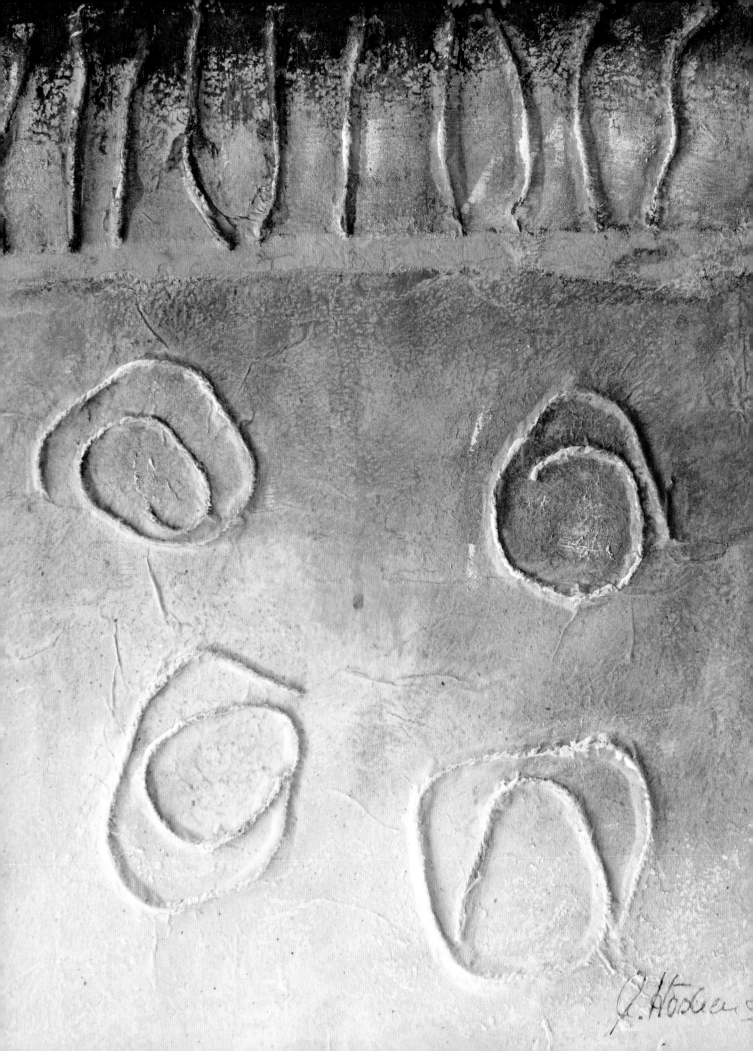

Twine under Chinese Paper

TASK AND MATERIALS

Focal points

Colour, space, line, pattern, balance, dominance

Equipment

Flat brush, spray bottle, scissors

Materials

Stretched canvas: 40 x 60cm (15¾ x 23½in), graphite stick, acrylic binder, Chinese paper with and without frottage, twine

Acrylic paints: Titanium White, Warm Grey, Golden Ochre, Vandyke Brown, Silver

Aero Colors: Supra White, Brown Brazil, Sepia

Oil pastels: Titanium White, Orange

Original format

INSTRUCTIONS

Arrange some twine cut into equal lengths. Try things out. When you are happy with the composition, place the pieces in the acrylic binder, which you have already painted on, and stick Chinese paper over it. Press the paper well with the flat brush so that it adheres to the twine properly. Granulate some of the space from each side of the picture using Warm Grey and Golden Ochre. Glaze the picture from the lower edge inwards with Supra White. In separate layers, glaze it from the upper edge with Brown Brazil and Sepia, and spray the edges with water. From the upper edge of the picture, granulate Vandyke Brown softly over the ends of the twine. Apply a stripe of Silver along the line marking the upper third, and spray the edges with water. Finally, granulate Titanium White and Orange oil pastels over the projecting strings to emphasize their tactile quality.

Variation: Use the graphite stick to frottage different patterns onto the rest of the Chinese paper, and collage the remaining space with it.

Before applying the paint, you can see the individual frottages.

Subtle pencil outlines accentuate the paper edges.

PICTURE
COMPOSITION

The rules for constructing pictures are also practised in abstract painting. In addition to the choice of format, which precedes everything else, the focus here is on the principles of composition.

CHOICE OF FORMAT

The choice of format should not be overlooked; the format should be consciously chosen to determine the expressiveness of your image. In addition to the standard squares and rectangles, there are immense possibilities for exciting, extreme formats. On very narrow portrait formats or on extremely wide and flat landscape formats, the same motifs appear much more exciting and dynamic.

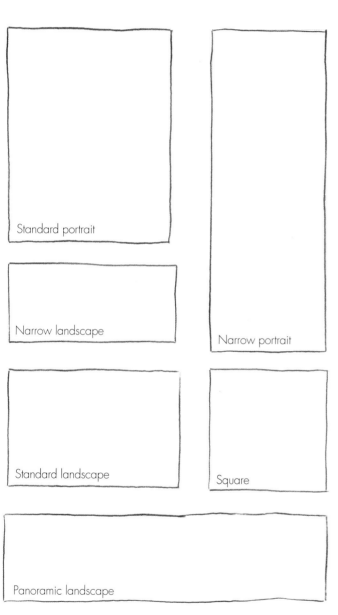

Standard portrait

Narrow landscape

Narrow portrait

Standard landscape

Square

Panoramic landscape

First, think about the selection of possible formats.

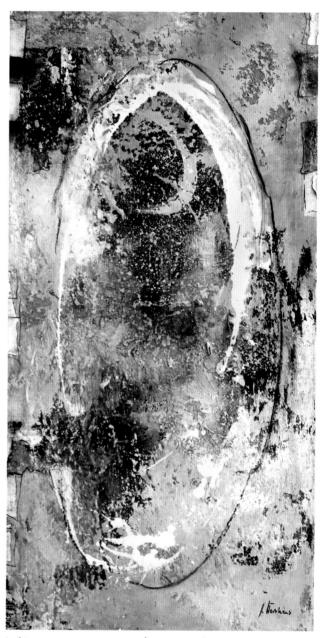

In this case, a narrow portrait format was chosen.

RULES OF COMPOSITION

The laws that govern spatial relationships and the arrangement or positioning of forms and colours within an image are called 'the rules of composition'. The observance of these rules is also common in the Art Informel and abstract realms, but is seldom as obvious as in realistic representations. Secondary visual expressions are made through different arrangements, for instance to bring tension or calm into the subject. If you want to realize a certain idea or abstract a template, you can arrange the composition in advance, by means of well-considered and sketched-out drafts. If you start without a preconceived idea and with the aim of letting your work flow, the composition will develop spontaneously out of the working process. In any case, the rules of the Golden Section and of diagonal composition shall form the basis.

GOLDEN SECTION

The subject of this rule is the division of spaces into relative proportions, which is considered to be the model of aesthetic proportioning. In order to arouse the viewer's interest and to create tension and vibrancy, irregularity or asymmetry is preferred to boring uniformity. In its simplest and most intelligible form, the Golden Section means the dividing of the space in a ratio of two-thirds to one-third.

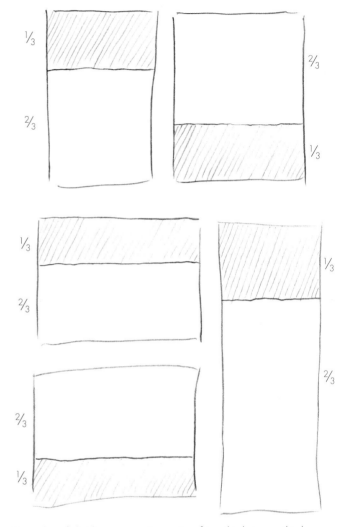

Examples of dividing spaces in a ratio of two-thirds to one-third.

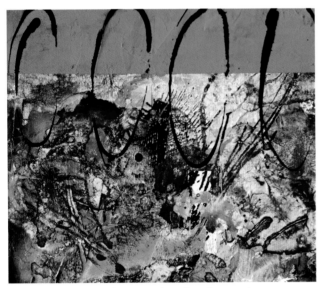

The clear separation of spaces takes place here on the upper third line.

After the horizontal division, the image is also divided into thirds vertically. This results in a total of four intersections. One of these intersections is chosen as the Golden Intersection, i.e. the focus of interest of the image. This area is given full attention; it is actively emphasized with the help of the primary picture elements, while the other areas are less pronounced.

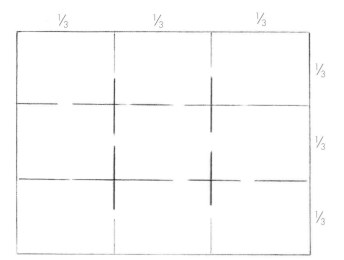

Subsequent vertical division into thirds results in four intersections.

In this subject, the centre is at the upper-left intersection.

DIAGONAL COMPOSITION

The guiding, diagonal arrangement of forms or a corresponding line increases the energy and dynamics of an image. The picture appears more pleasing when certain elements run over these lines. Diagonals convey movement and produce different effects, depending on their orientation. Due to our familiar direction of reading, diagonals running 'from left to right' are perceived as pleasing; the opposite diagonals, conversely, are perceived as jarring. The ascending line of vision appears positive, the descending one rather negative. Diagonal leading lines are not always discernible at first glance, but lead the beholder along 'imaginary paths' through the picture. A professional painter leaves nothing to chance, but rather uses such directional cues to navigate us through their work.

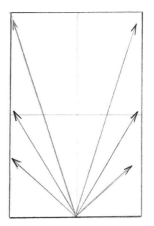 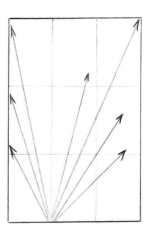

The two-thirds division also applies here; the extension of the diagonals from the left third line (see illustration on the right), causes considerably more tension and dynamics than a central arrangement.

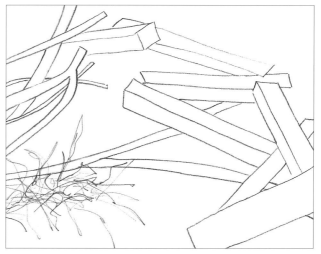

Here, you wander through the picture via the individual elements on diagonals.

POINTS OF ENTRY AND EXIT

Create an entry point to the picture (i.e. where contact with the viewer is established). From this entry point, you can lead the viewer to the concentrated arrangement of objects in the Golden Section, by means of active areas that attract attention. The viewer is guided to the most significant elements as if by an invisible hand, and finds their way out again in the same way. This is pleasant and inviting, and it is easier to be unconsciously guided by the painter instead of having to painstakingly find your own way through a picture.

By weighting colours and spaces, the viewer can be guided in different ways despite the same picture layout. In the following examples, which are based on the same drawing as in the picture below left, the difference becomes clearly visible through the different spatial designs. In this way, for example, the focus is maintained by highlighting the spaces in the area of the Golden Intersection in the lower left third; the original leading lines do not match this intensity of colour and so are rendered ineffective.

The viewer has to take a detour in order to be able to enter at the right edge of the picture.

The combination of individual spaces in red results in a clear division of space in a ratio of about two-thirds to one-third.

The viewer can comfortably enter the picture from the bottom left, and is guided back to the bottom left via the right vertical.

The left vertical and the upper horizontal third lines are accentuated by the diagonal meshing of small spaces.

PRACTICE

Inspired by the forms and textures of a rubble-filled forest path, this coarsely textured work was created based on several preliminary sketches.

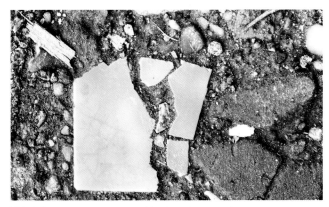

Work from an image source like this photograph.

Sketches on different formats

INSTRUCTIONS

The forms of the fragments in the photo have been adopted here in a free arrangement. The loose stones on the forest floor inspired me to use this stencil.

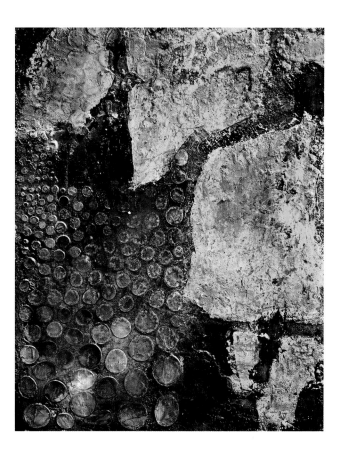

Take an opaque underpainting in Indian Yellow and glaze it with some slightly diluted Alizarin Crimson. In order to recreate the composition of the forest floor, mix paste with silica sand and, using a spatula, apply the mixture across the greater part of the painting surface in generous motions. You can leave any spontaneously occurring gaps in the texture application free, in order to maintain a view of the blank canvas. Glaze the entire picture surface with Warm Grey. Now apply a stencil (in this case, a pattern with circles of different sizes). Mix paste with some ash, and, using a spatula, fill in the holes of the stencil. After the stencil has been removed, the pattern appears tactile, with sharp edges. Use slightly diluted Vandyke Brown and a flat brush to glaze over the entire space. Now draw in the desired shapes with charcoal. First, fill these in with Green Yellow. Then, partially cover the still-damp paint with a second layer of Green Earth.

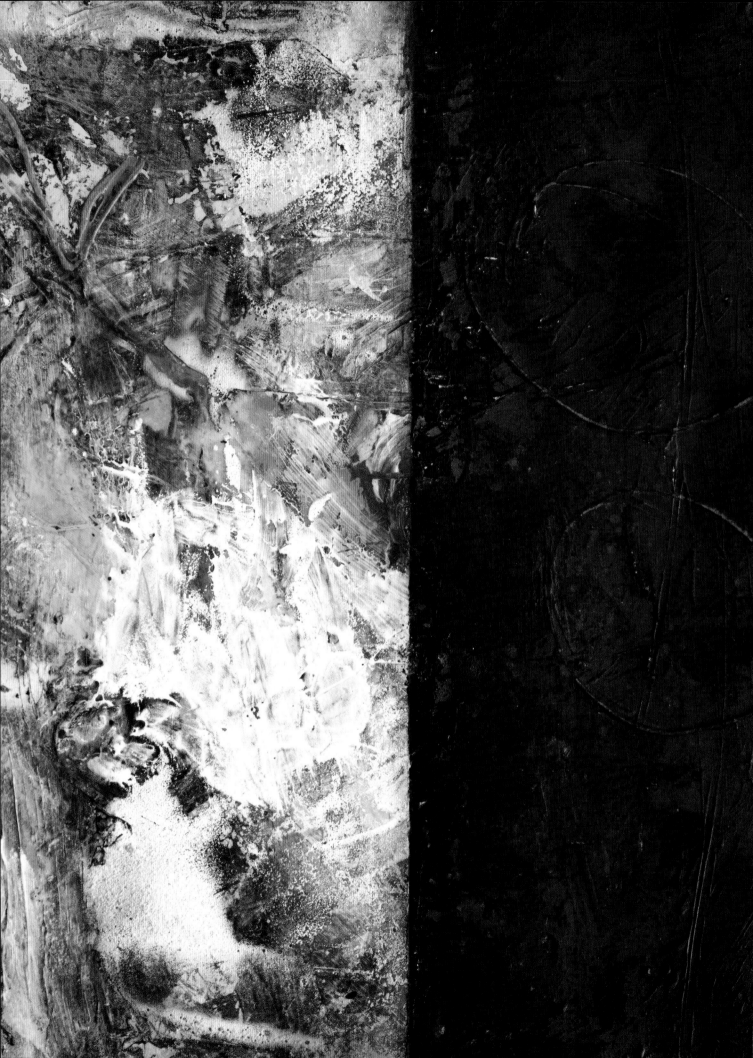

Vertical Thirds

TASK AND MATERIALS

Focal points

Colour, space, line, dynamics, contrast

Equipment

Spatula, flat brush, pencil, spray bottle, dosing bottle with nozzle

Material

Stretched canvas: 60 x 90cm (23½ x 35½in)

Acrylic paints: Titanium White, Magenta, May Green, Hooker's Green, Primary Yellow, Yellow Ochre, Black

Oil pastels: Titanium White, Orange

Original format

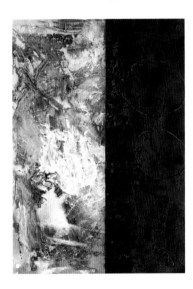

INSTRUCTIONS

Use the spatula to add paste freely onto the central area of the canvas. Use a pencil to scribble tracks into the moist paste. This work has developed accidentally, so to speak. I like to use my remaining paint from work on other paintings, taking the leftovers and playing with them in multi-layered glazes without prior planning. Spatula or paint on each colour freely, dilute the rest, and splatter and spray the paint. The order in which various layers are applied is eventually no longer discernible. They overlap in parts, so that only a small area of the lower layers remains visible. Finally, calm the work down by painting over a little more than a third of the space in Black impasto. Subtle ovals, painted in magenta with the dosing bottle and a fine nozzle, create a connection to the colourful space.

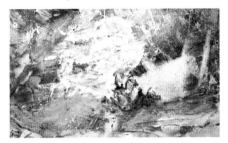

Entire surface without black overpainting

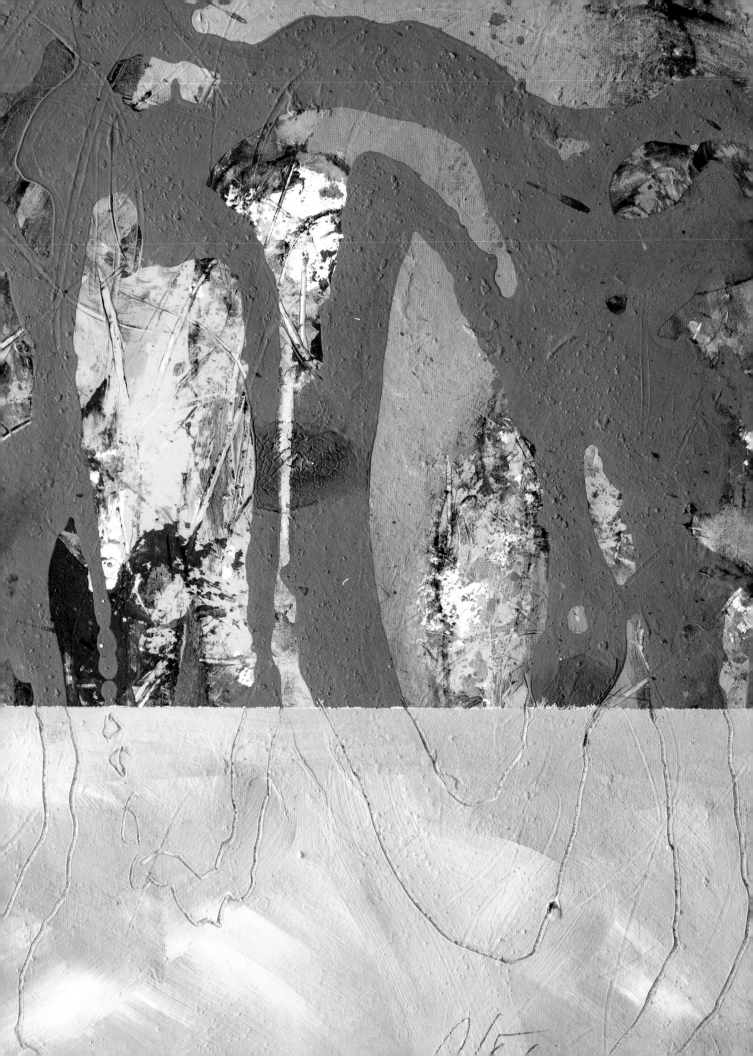

Joining Spaces through Engraving

TASK AND MATERIALS

Focal points

Colour, space, line, form, texture, pattern, variation, contrast, repetition

Equipment

Spatula, flat brush, masking tape, pencil, spray bottle, dosing bottle

Material

Stretched canvas: 60 x 90cm (23½ x 35½in)

Acrylic paints: Primary Yellow, Hooker's Green, Titanium White, Orange, Sand, Yellow Ochre, Burnt Sienna, Vandyke Brown, Primary Magenta, Primary Cyan

Original format

INSTRUCTIONS

To create the underpainting, Yellow and Hooker's Green are first applied impasto, freely with a spatula. Apply the two colours next to each other and into each other in a loose sequence; these random mixtures result in various nuances of colour. Use a pencil to scribble into the wet paints. Finally, dilute the remaining paint and splatter it onto the painting support with the flat brush. According to your instinct, spray water on some areas of the paint. Apply some highlights in White with the spatula. In a second layer, repeat the first step with the related colours Yellow, Orange, Sand, Yellow Ochre, Burnt Sienna and Vandyke Brown. Leave the first application visible in some areas. Dilute a mixture of Titanium White and Magenta in a dosing bottle and paint sweeping traces of colour with the nozzle onto the spatula-worked space; repeat the technique with Cyan. Mask off a little more than one-third with masking tape and calm the work by covering the space with an impasto overpainting in Titanium White and Yellow Ochre. Finally, score the extension of the outlines of the blue colour tracks into the wet paint with the pencil.

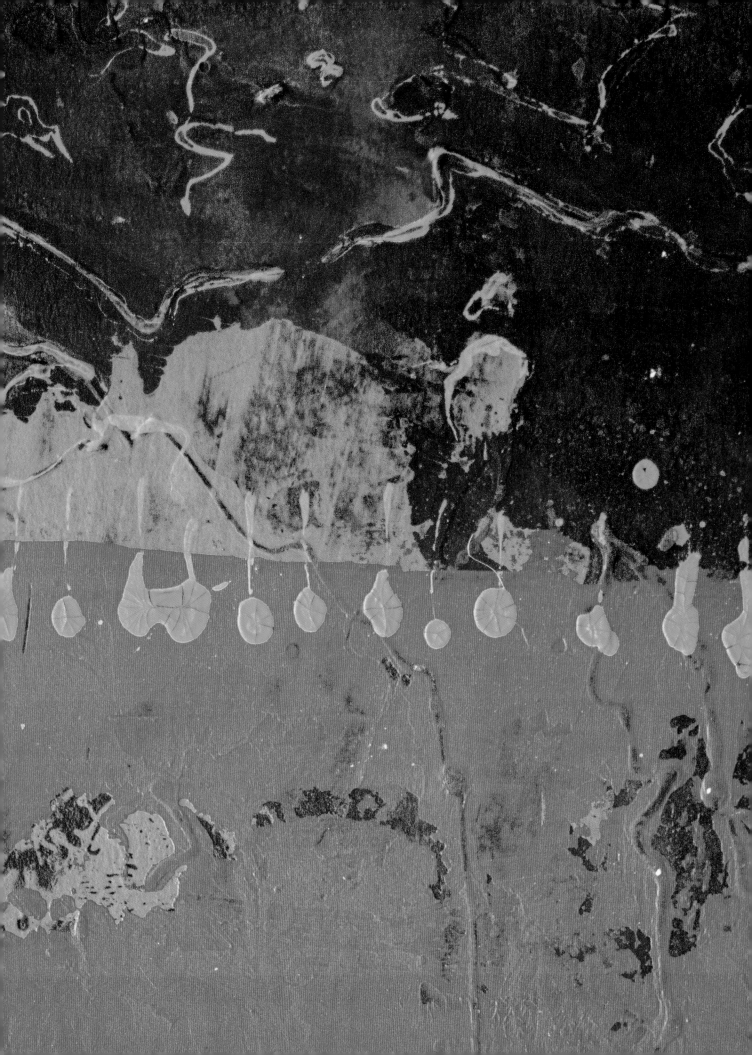

Joining Spaces through Pattern

TASK AND MATERIALS

Focal points

Colour, space, line, pattern, dynamics, variation, contrast

Equipment

Spatula, flat brush, bottle with pointed nozzle, pipette

Material

Stretched canvas: 60 x 90cm (23½ x 35½in)

Acrylic paints: Cadmium Red, Burnt Sienna, May Green, Cobalt Turquoise, Black

Original format

INSTRUCTIONS

Using the spatula, apply Burnt Sienna and Black freely as a loose underpainting over the entire space. Glaze the picture with Cadmium Red. Put May Green into a bottle with a pointed nozzle and draw some tactile lines freely. Use a spatula to granulate Cobalt Turquoise into the central area of the canvas. Calm the work down by covering approximately two-thirds of the space with a strong Cadmium Red impasto. Leave gaps in the paint application in order to be able to see the lower layers. Finally, connect the two unequal colour spaces with drawn-in patterns such as dashed lines and dots, using a pipette and diluted Cobalt Turquoise.

The background of this version has been laid out with texture and a newspaper collage.

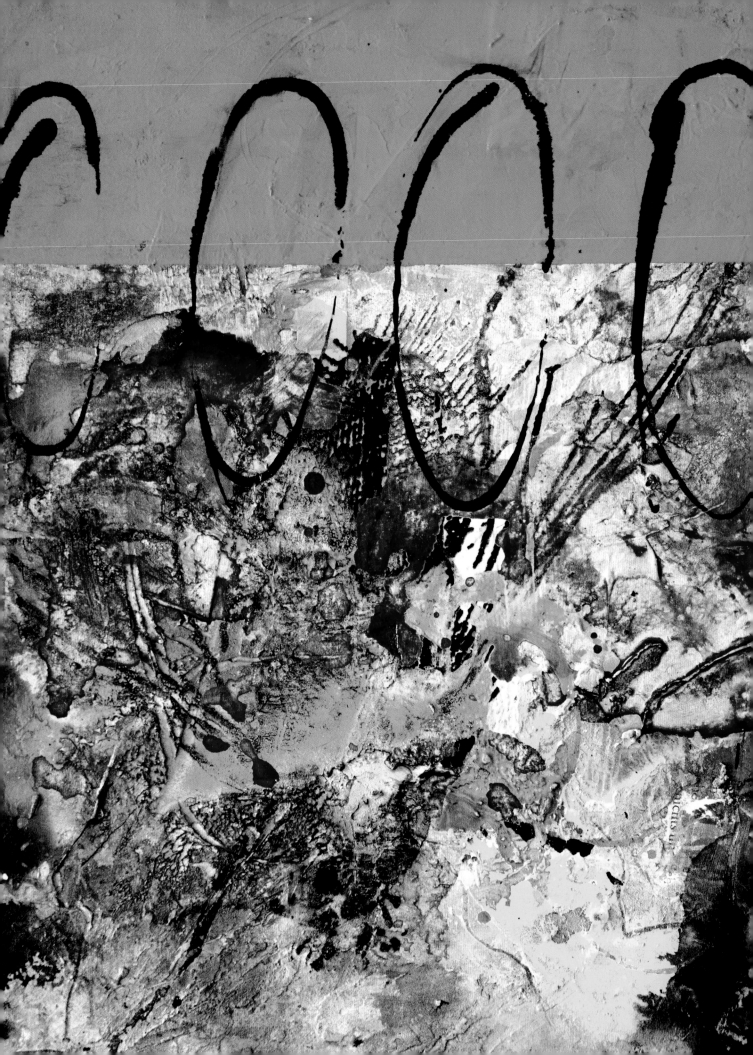

Joining Spaces through Drawing

TASK AND MATERIALS

Focal points

Colour, space, line, pattern, dynamics, variation, contrast

Equipment

Spatula, flat brush, spray bottle, pipette

Materials

Stretched canvas: 60 x 90cm (23½ x 35½in), light texture paste

Acrylic paints: Black, Burnt Umber, Magenta, Cyan, May Green, Yellow, Brilliant Violet, Cobalt Blue, Cobalt Turquoise

Original format

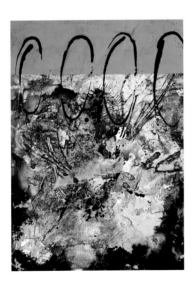

INSTRUCTIONS

Paint large patches of undiluted Black and Burnt Umber freely. Cover the entire space in a thin layer of paste with the flat brush without prior planning – but do not paste over the underlying texture. Now, you will play with multi-layered glazes. Pay attention to the suitability of the shades in terms of colour theory, and avoid direct contact of complementary colours. It is best to work in the following order: Yellow, May Green, Cobalt Blue, Cyan, Magenta, and Violet. To do this, dilute each colour and pour it onto the painting support medium. Splatter on any remaining paint with the flat brush and spray the edges of the colour with water as required. Overlap each colour in parts, while some areas of the lower layers remain visible. Finally, calm the work down by overpainting the entire upper third impasto in a strong Cobalt Turquoise. In this case, dynamic ovals painted in diluted Black using a pipette connect the two unequal colour spaces.

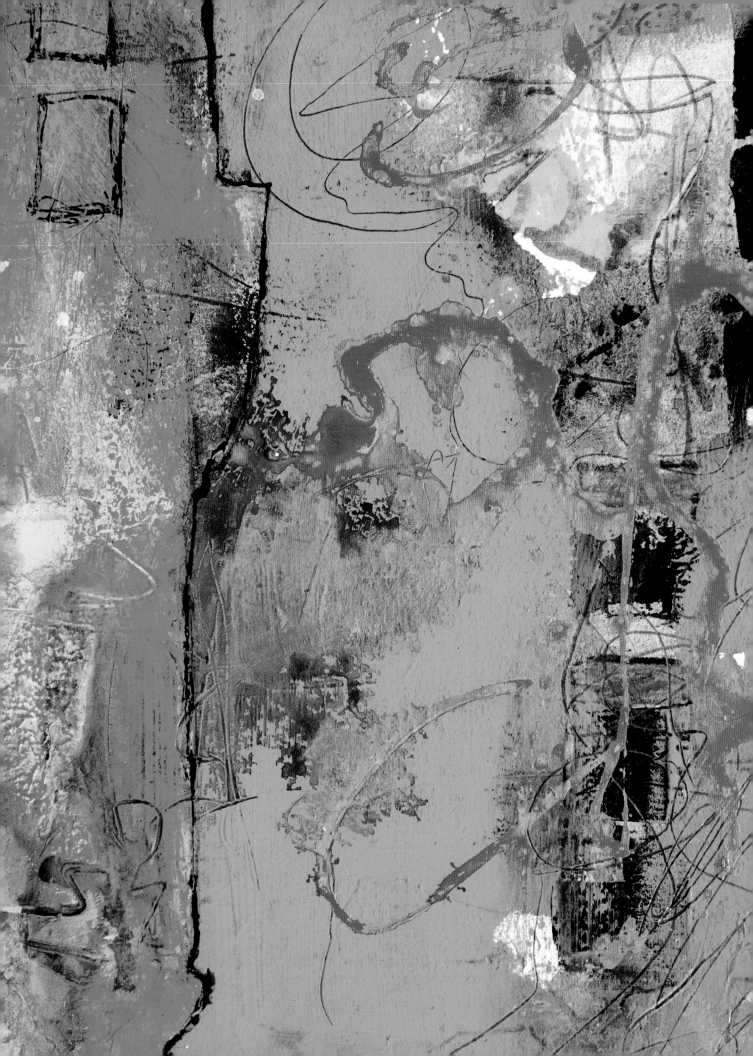

Loose Division of Space through Outlines

TASK AND MATERIALS

Focal points

Colour, space, line, form, pattern, dynamics, variation, contrast

Equipment

Spatula, flat brush, bristle brush, spray bottle, pipette, pencil

Materials

Stretched canvas: 60 x 90cm (23½ x 35½in), light texture paste

Acrylic paints: Magenta, Cyan, May Green, Naples Yellow, Pebble Grey, Titanium White, Black

Aero Color: Ultramarine, Golden Ochre

Original format

INSTRUCTIONS

Using a spatula, apply paste freely onto the central area of the canvas. Scribble some tracks into the damp paste with the pencil. Apply an opaque underpainting in Pebble Grey. Using a bristle brush, splatter and spray a glaze in Ultramarine over some areas, and repeat this process with Golden Ochre. With the flat brush, paint a row of opaque black squares on the line of the right vertical third. Apply an impasto layer of Cyan over approximately two thirds of the space, granulating in some areas to obscure the clarity of the underlying paint applications. With the pencil, scribble some loose traces of movement in the still-damp paint. On an irregular bar on the left edge of the picture granulated in Naples Yellow, partially glaze a strong May Green. In a thick mixture of Magenta and Titanium White, draw free lines with the pipette and spray these in some areas. Finally, use the pipette to draw playful black outlines, thus separating the two large spaces from each other.

COLOUR

Colour lends atmosphere and allure to a work of art. Colours can radiate calm and harmony, or aggression; they are, so to speak, the messengers of emotion. In this lesson, you will acquire the basic knowledge about mixing colours, colour relationships, and their effects in a picture.

THE COLOUR WHEEL

The representation of basic and mixed colours in a circle was founded on Isaac Newton's theory of colours. Arranged in a colour wheel, the 'relationships' between colours can be represented perfectly:

- In the middle are the primary colours.
- The secondary colours, each mixed from two primary colours, follow them.
- On the outer ring, the tertiary colours are located between the respective hues.
- Colours which lie directly opposite each other on the wheel are called complementary colours.
- Colours that lie next to each other in the colour wheel are referred to as analogous colours.

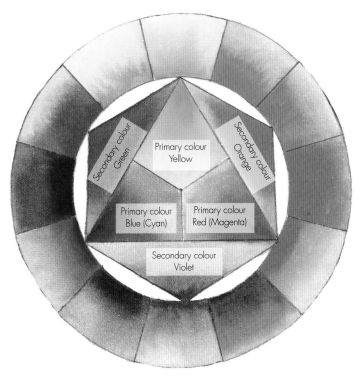

DEFINITION OF TERMS

- The generic term **colour** designates the colour itself, such as 'red' or 'blue'.
- The **shades** are differentiated within this scope, e.g. 'pink red', 'tomato red' or 'dark red'.
- A third technical term is the so-called **'tint'**: this is when a colour has a barely visible hint of an added colour, for example a 'blue tinted grey'.

PRIMARY COLOURS

The theory of colours is based on the so-called primary colours. Pure yellow, red and blue cannot be mixed from other colours; however, when mixed together, all other colours (except white) can be produced. Since each manufacturer names its basic colours differently, no universally valid colour designation can be recommended; the modified colour series calls them Primary Yellow, Primary Magenta and Primary Cyan.

SECONDARY COLOURS

In the first mixing (i.e. when you mix two primary colours with each other) you obtain the following secondary colours:

- Magenta + Yellow = Orange
- Yellow + Cyan = Green
- Cyan + Magenta = Violet.

TERTIARY COLOURS

If a primary colour is mixed with an analogous secondary colour, the tertiary colours are produced:

- Yellow-green and blue-green when mixed with green
- Yellow-orange and red-orange when mixed with orange
- Red-violet and blue-violet when mixed with violet.

FURTHER GRADATIONS OF COLOUR

Different proportions of colour produce a multitude of different tonal gradations. The results obtained can be used to create countless colour variations by further mixing them in pairs. The resulting nuance depends on the version of each basic shade.

PRACTICE

To obtain a specific shade, start with a basic colour and make any necessary changes.

If you mix in advance on the palette, note the following:

- Always start mixing with the lighter colour.
- Carefully add the darker colour, in order to gradually get closer to the desired shade.
- Once you have reached the approximate shade, you can nuance it and approximate to a specific colour.
- Correct the mixing results in small steps, or with small amounts of another colour.
- Leave different tonal values in the mix; do not blend the colour into a dead, uniform mass.

Mixing can also be performed directly on the painting support medium using various techniques:

- Wet-in-wet on the moistened painting support medium; the colours flow together and find their own way
- In overlapping translucent glazes – this is an optical mixing, since the individual layers of paint are merely superimposed and thus cannot be separated by the eye
- Pastose or diluted, rubbed into each other
- Partially juxtaposed (Pointillism)
- Granulated overlaying (the translucent painting technique).

Test swatches allow a direct comparison of the mixing results.

INTERACTION

The eye does not see colours in isolation, but in their collective context. All colours and shades influence each other. Each new splash of colour in an image changes the relationship between the existing colours. The colour's shade and strength play an important role. Within the scope of this interaction, there are certain relationships between colours, the principles of which are indispensable in the composition of abstract or Art Informel pictures.

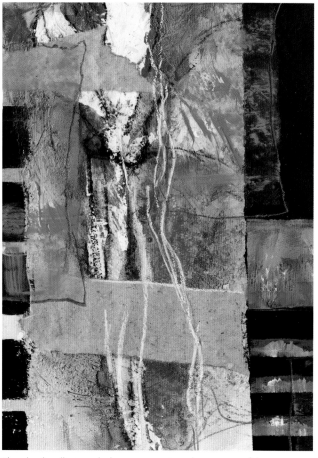

The shades illustrated above merge into the entirety of the picture.

VARIATIONS

- **Cold–warm contrast** – All colours can be divided into cold and warm colours. Thus, comparing all shades, the yellow-orange-red shades are warmer than the green-blue-violet ones. However, there are warm and cold tones of each colour (such as for example, a warm blue and a cold blue).

- **Complementary contrast** – The mixture of two primary colours (e.g. yellow and red) gives the complementary colour of the third primary colour. Complementary colours positioned next to each other help to achieve more luminosity; mixed together, the pure shades destroy each other to form broken shades of grey.

- **Colour tones** – A colour tone consists of related colours, i.e. those that lie next to each other in the colour circle. Mixing two basic colours creates an entire colour hue such as, for example, all shades of yellow, green and blue.

- **Tonal value painting** – The tonal value describes the degree of intensity with which a colour is applied. This ranges from highest saturation to transparency, or from purity to the strongest lightening with white or darkening with black.

- **Monochrome painting** – In monochrome painting, the artist limits him/herself to the use of one colour, but has many shades, such as, for example, different shades of blue. If only grey tones are used, it is called 'grisaille'.

In an overall comparison, the area of green–blue–violet shades is classified as cold, and that of yellow–orange–red shades as warm.

PRACTICE

A large part of the composition can already be clarified using tonal sketches. Test the effect using several colour variations. An expressive effect is achieved, for example, by a strong opposition between light and dark, or in a complementary contrast.

Strong light–dark contrast

Harmonious colour tones

Complementary contrast

Red–Orange–White Gradation

TASK AND MATERIALS

Focal points

Colour, space, gradation, dynamics, variation, contrast

Equipment

Spatula, flat brush, dosing bottle, pipette, spray bottle, bowl

Material

Stretched canvas: 60 x 100cm (23½ x 39½in)

Acrylic paints: Burnt Sienna, Orange, Cadmium Red

Spray paint: Silver marble effect

Aero Colors: Madder Red, Supra White

Original format

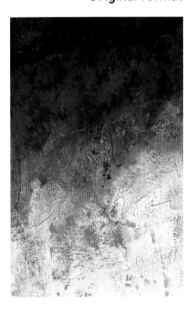

INSTRUCTIONS

Taking an opaque Burnt Sienna underpainting extending over the majority of the canvas, use the spatula to apply some Cadmium Red and Orange, one into the other. Put some undiluted Orange into a dosing bottle and write a raised texture in illegible handwriting on the upper two-thirds of the picture surface. Repeat this writing with the Silver marble spray paint. Use the pipette to apply Supra White to the lower edge of the picture, and use the spray bottle to spray soft transitions towards the centre of the image. Repeat the process at the upper edge of the picture with Madder Red, and, finally, swipe out the paint residues on the brush onto the picture surface.

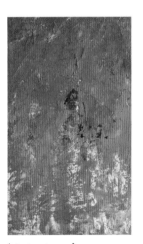

Interim stage 1 Interim stage 2

TIP

Illegible textures always seem a bit mysterious and attract the observer's attention involuntarily.

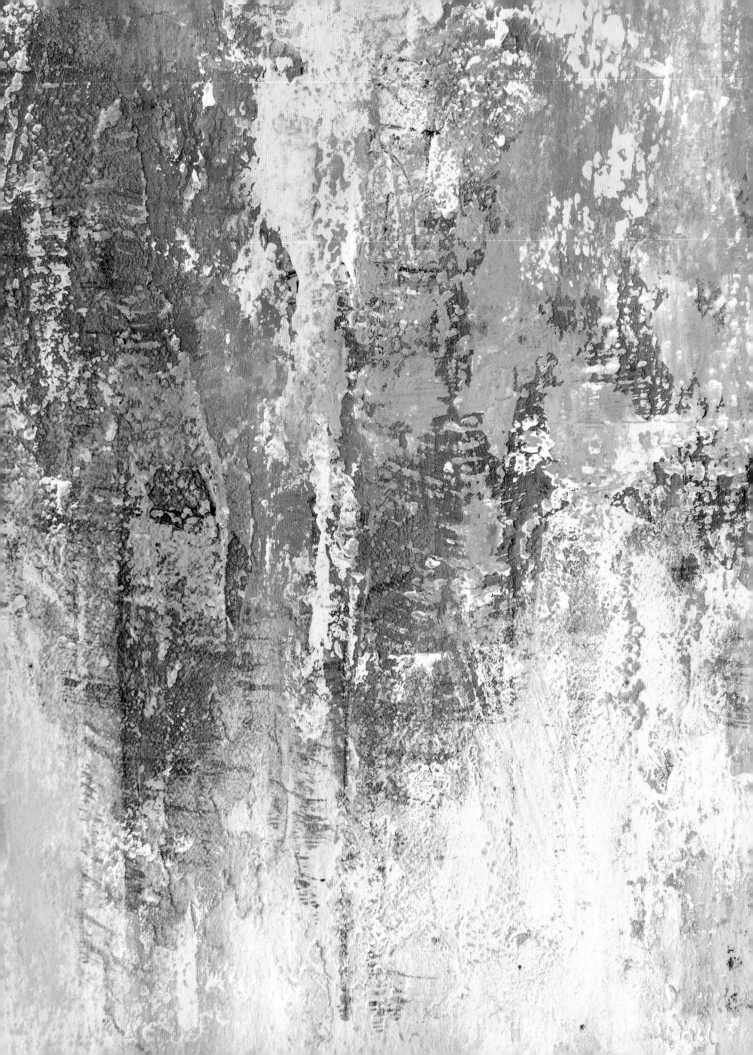

Blue–Green–White Textures with the Spatula

TASK AND MATERIALS

Focal points

Colour, space, texture, harmony, variation, contrast

Equipment

Spatula, flat brush

Material

Stretched canvas: 40 x 60cm (15¾ x 23½in)

Acrylic paints: Titanium White, Black, Burnt Sienna, May Green, Royal Blue, Cobalt Turquoise

Original format

INSTRUCTIONS

Use Burnt Sienna and a little Black to apply an opaque underpainting to the upper half of the picture. When they are dry, apply a loose mixture of Cobalt Turquoise, Royal Blue and White in vertical strokes. Leave small gaps in the applied paint, and let the colours run softly into the lightness. Then, apply the individual shades of blue and green impasto in the upper third with the spatula, paying attention to partial overlapping of the individual colour applications, and just brush out the residual paint into the lower third of the picture area. Begin with Cobalt Turquoise; start at the upper edge and rub downwards in vertical motions. Proceed in the same way with Royal Blue, Titanium White and, in the last step, May Green. Allow each layer of paint to harden in between to create fine, tactile paint textures.

TIP

Pictures in analogous colours (here, shades of blue and green exclusively) always exude a certain calm.

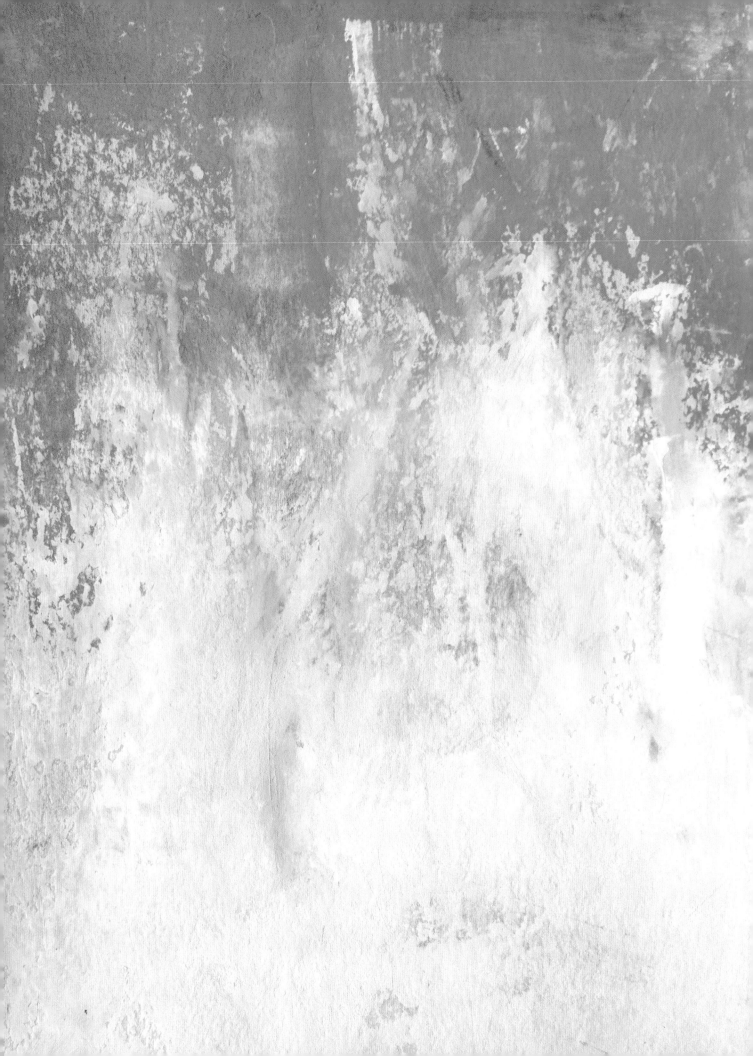

Subtle Complementary Contrast

TASK AND MATERIALS

Focal points

Colour, space, texture, harmony, complementary contrast

Equipment

Spatula, flat brush

Material

Stretched canvas: 40 x 60cm (15¾ x 23½in)

Acrylic paints: Titanium White, May Green, Primary Cyan, Primary Magenta

Original format

INSTRUCTIONS

Cover with an opaque underpainting using the flat brush; Primary Cyan in the upper third, and Primary Magenta in the middle third and softly graduating downwards. Then glaze Titanium White over the entire picture surface. Allow each layer of paint to harden in between. Now use a spatula to apply impasto May Green in the upper third of the image, and just brush out the residual paint onto the lower third of the picture surface. Without letting this paint application dry, apply Titanium White in the same way from the opposite end of the canvas, and rub the two colours into the overlapping area to create a pastel colour gradient. Leave small gaps in the paint application where the underpainting can shimmer through.

TIP

The complementary contrast was moderated by the subtle background use of red, and by its softening of the pastel reworking.

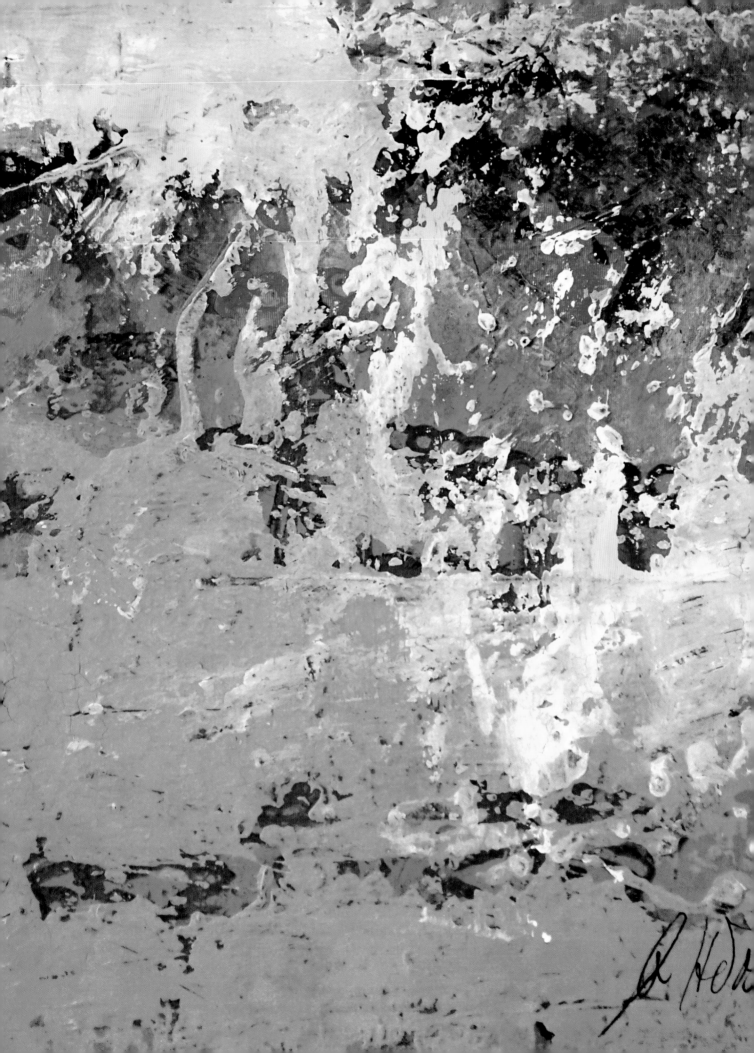

Accented Complementary Contrast

TASK AND MATERIALS

Focal points

Colour, space, texture, harmony, complementary contrast

Equipment

Spatula, flat brush, pipette

Material

Stretched canvas: 40 x 40cm (15¾ x 15¾in)

Acrylic paints: Burnt Sienna, Black, Titanium White, May Green, Cobalt Turquoise, Primary Cyan

Aero Color: Primary Magenta

Original format

INSTRUCTIONS

Using the flat brush, apply an opaque underpainting in Burnt Sienna and a little Black; the partial mixture produces various dull grey and brown tones. After it has dried, loosely paint on Cobalt Turquoise and Primary Cyan. Leave clear gaps in the paint application so that you can see the shades of the underpainting. Now, with the pipette, apply Primary Magenta in round splotches in the upper third. Once this has dried, use the spatula to apply an impasto layer of May Green to the lower third, and simply brush out the residual paint into the upper third of the picture surface. Without letting this paint application dry, apply Titanium White to some areas of the canvas in the same way; in the overlapping areas, rub the two damp colours together to create a pastel colour gradation. Make sure that neither the Magenta splotches nor the underpainting are completely covered.

TIP

The accented complementary contrast in Magenta enhances the luminosity of the relatively large green space.

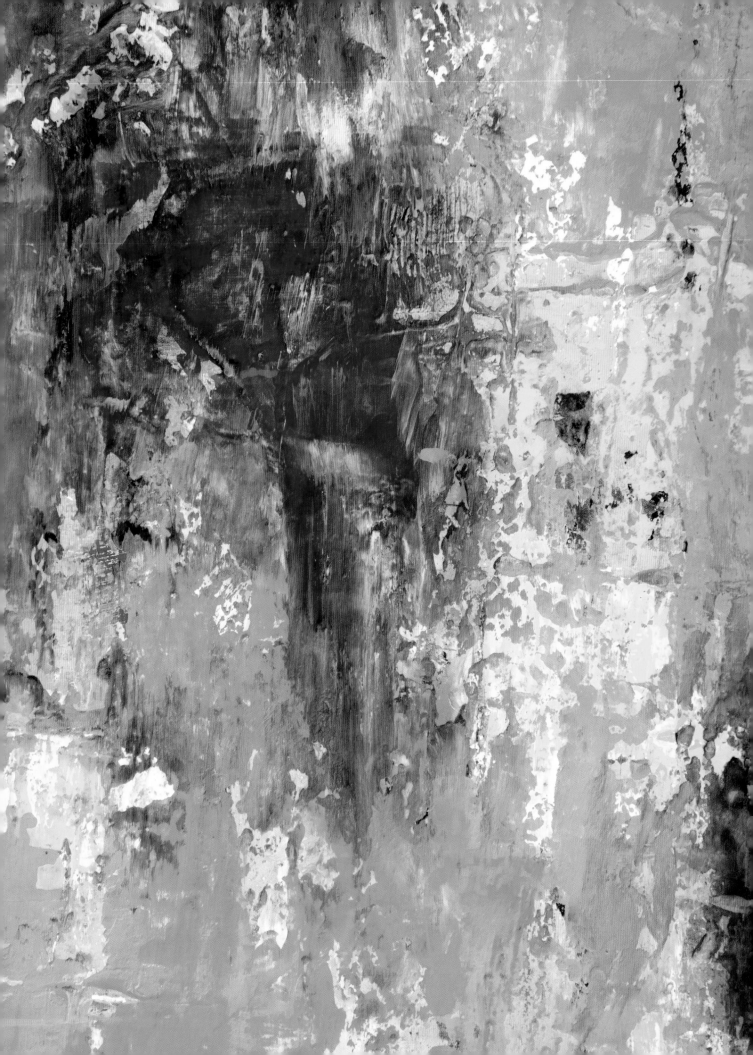

Complementary Contrast in the Golden Section

TASK AND MATERIALS

Focal points

Colour, space, harmony, rhythm, focus, colour tone, complementary contrast

Equipment

Spatula

Material

Stretched canvas: 40 x 60cm (15¾ x 23½in)

Acrylic paints: Titanium White, May Green, Cobalt Turquoise, Primary Yellow, Primary Cyan, Primary Magenta, Alizarin Crimson, Vandyke Brown, Pebble Grey

Original format

INSTRUCTIONS

Start by applying Vandyke Brown and Pebble Grey into each other with a spatula over the entire space; the partial mixture produces various dull shades of grey and brown. In the next layer, apply Yellow and May Green in the same way. Leave clear gaps in the paint application so that you can see the shades of the lower layers. To loosen it up, add in a few light spots with Titanium White. Next, add a coat of Cobalt Turquoise and Cyan, this time starting from the edge of the picture and working it inwards with a spatula. As soon as this layer has slightly taken, create a Magenta and Alizarin Crimson space in the area of the upper left Golden Section. Blend the transitions into the surrounding semi-damp areas; the mixture of Magenta and Cobalt Turquoise creates various shades of purple.

TIP

The muted shades of red make both the underlying May Green and the spaces in the areas of Cobalt Turquoise glow.

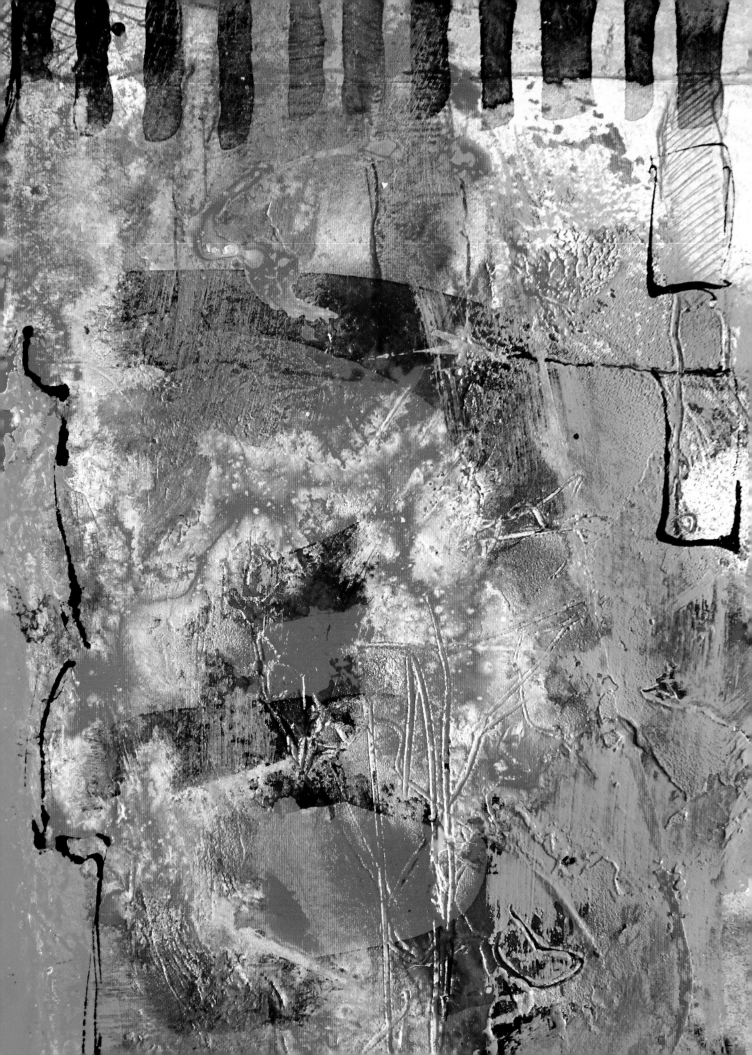

Vibrant Complementary Contrast

TASK AND MATERIALS

Focal points

Colour, space, form, pattern, dynamics, variation, contrast

Equipment

Spatula, spray bottle, pipette, pencil

Materials

Stretched canvas: 100 x 150cm (39½ x 59in), light texture paste

Acrylic paints: Magenta, Cyan, May Green, Titanium White, Black

Original format

INSTRUCTIONS

Using a spatula, apply paste freely to the central area of the canvas. Scribble some tracks into the damp paste with the pencil. Apply an opaque underpainting in Magenta, and, starting from around the edges, paint on a glaze in May Green. Glaze patterns on using diluted Black; stripes at the upper edge of the picture and broad, truncated ovals. Using a dry glaze in Cyan, obscure the clarity of some areas of the underlying paint applications. On the left edge of the picture, glaze an irregular strip in a vibrant May Green. Using a creamy mixture of Magenta and Titanium White, draw free lines with the pipette, spraying this in some areas. Finally, draw playful outlines with the pipette in Black. Additional hatching with a pencil rounds off the work.

TIP

There is no shortage of luminosity. Three pure colours – May Green, Magenta and Cyan – dominate the cheerful and dynamic-looking picture.

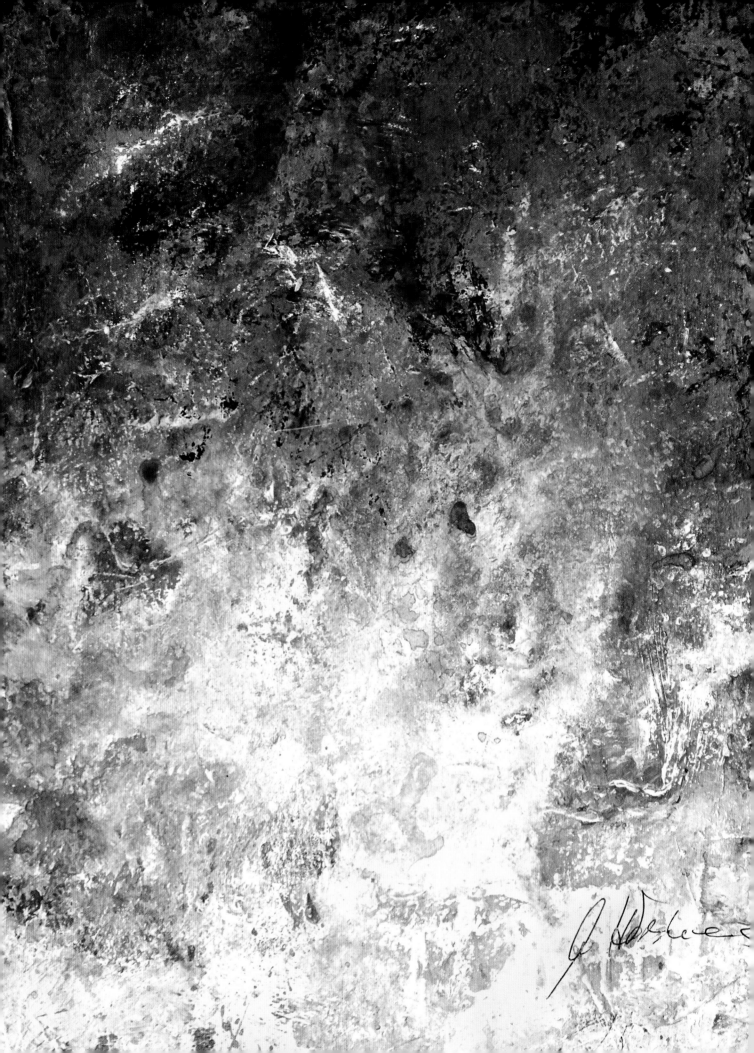

Monochrome Painting with Cyan

TASK AND MATERIALS

Focal points

Colour, space, gradation, harmony, contrast

Equipment

Spatula, flat brush, spray bottle

Material

Stretched canvas: 60 x 90cm (23½ x 35½in)

Acrylic paints: Titanium White, Green Earth, Cyan, Vandyke Brown, Royal Blue, Magenta, Yellow Ochre

Original format

INSTRUCTIONS

Using a spatula and some leftover paints in Yellow Ochre, Magenta and Royal Blue, paint an opaque underpainting onto the main part of the canvas. Then, starting at the upper edge and using the flat brush, paint over in Cyan. Leave a view of the underpainting partially free. Granulate Green Earth with a spatula to about the middle of the picture, and then swipe the diluted paint residues on the brush across the picture surface. Starting from the lower edge of the picture, granulate Titanium White with a spatula and use the spray bottle to spray soft transitions towards the centre of the picture. Repeat the process from the upper edge of the picture with Vandyke Brown, and, finally, swipe out the paint residues on the brush onto the picture surface.

TIP

If monochrome images in earthy shades seem too plain, you can liven them up by using a bright colour, like Cyan here.

SPACE

The division of space determines the composition of the picture. The expressive role of spaces is defined by dual opposites. Thus, small spaces are contrasted with large spaces, coloured spaces with plain spaces, light spaces with dark spaces. Spaces can be open or closed, or be differentiated from each other through the use of different textures.

DEFINITION OF TERMS

- Open spaces stretch into the background.
- Delimited spaces stand out from the rest of the space.
- Spatial boundaries that extend to the edge of the picture surface extend the territory. They suggest the continuation of the space outside the painting support.
- Positive (delimited spaces) contrast with negative spaces (surrounding background).

PRACTICE

With a brush, you can stroke, rub, brush or blur, or just press, dab and tap. With a paint roller, sponge or cloth, you can extend these application possibilities and achieve different surface textures. With the spatula, you can, for instance, scrape, glide or scratch. Experiment with unconventional means. Press a ball of crumpled newspaper into damp colour spaces, or stamp them with bubble wrap. Place plastic food wrap on wet paint, and pull it off quickly when it is completely dry.

The appearance of the treated spaces plays a decisive role. For example, non-directional paint applications have a calming and unobtrusive effect, while expressive, intersecting applications appear interesting and lively. A diagonal paint application can even lead through the picture in a directional way. From the experiences gained through your own experiments, you will learn to use the material in your own personal way, and to achieve the desired effects.

VARIATIONS

- Dynamic, expressionistic, aggressive
- Sweeping, loose, impressionistic
- Horizontal, vertical, directional
- Crossing diagonally, striped, circling
- Smooth, uniform, directionless.

PAINTING TECHNIQUES

You can choose from a variety of basic techniques based on the diversity of materials and the use of different tools. Knowledge of the techniques and basic skills provide the foundation of a free painting process.

PASTOSE PAINTING STYLES

Covering with a brush
While the paint is wet, apply it using rapid back-and-forth movements of the brush, avoiding painting in one direction only. Since acrylic paint dries relatively quickly, it can only be applied within a limited time frame.

Always use both sides of the flat brush for applying paint.

Apply paint with the side edge of the spatula if you want to achieve precise, contrasting colour edges.

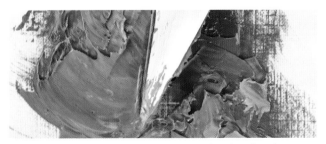

Apply paint with the spatula in expressive, disordered and overlapping movements without smoothing the traces over.

Covering with a paint roller, cloth or sponge

Lambswool or synthetic fibre rolls from art suppliers leave interesting application traces on large spaces. Slightly tactile textures can be achieved using smooth hard rubber rollers, such as those used for linoleum printing. Roll the paint evenly on a sheet of glass in advance in order to avoid unwanted irregularities. You can also rub acrylic paint on with a cloth or a household sponge. If you have applied too much paint, both are also suitable for corrective paint removal.

Pastose gradation

A gradation is a soft, barely perceptible transition from one shade to another, or to a tonal value of the same depth. In larger areas, smooth out the transitions between the individual shades until they are blended together. In smaller delimited spaces, tap or stipple both areas of colour together with the brush. Since acrylic paints dry quickly, you must work fast. You can keep the paint damp longer in large spaces by spraying it occasionally with a fine mist of water.

You can achieve even colour spaces with a paint roller.

Step 1: For a tonal gradation, begin by creating the shades next to each other in tonal values.

You can dab or rub with a household sponge.

Step 2: Then blend the transitions between the individual shades until they are all merged.

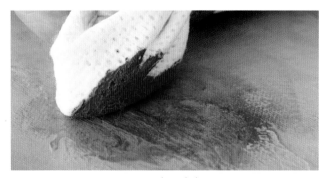

You can remove excess paint with a cloth.

You can also dab the colours into each other with the brush.

You can achieve cloudy patterns with circular motions.

GLAZE

Glazes are transparent layers of paint which are applied either over some areas of a picture or across its entirety. If you want only to intensify the shade which is already there, use the same colour. If you apply a different colour glaze, you can change the underlying shade. This is known as optical colour mixing, as the human eye cannot separate the superimposed layers, although the colours are not really mixed together. The finest tonal gradations can also be applied to dry, opaque coloured spaces. A glaze over the entire picture acts like a colour filter that is placed over the work.

Dilute acrylic paint into 'coloured water'.

Pastose glaze

You can achieve controlled, even glazes by adding colourless primer, viscous binder or painting gel to pastose paint. This creates transparency without changing the consistency of the paint. Apply the paint in a thin layer, by means of circular movements with a brush, cloth or sponge.

Spread the glaze with rapid movements onto the painting surface.

Aqueous glaze

These are strongly diluted or liquid acrylic paints, which are overlaid on top of each other like clear coloured glass panes, 'pane by pane', leading visually into depth. Each layer must be absolutely dry before the next layer is applied. Glazes can be applied with a brush or poured over the picture surface. Distribute the paint without spreading it evenly, by turning and tilting the painting support medium. You can create streaks by placing the painting support medium upright. Spray the edges of the paint with a spray bottle if you want to create soft transitions.

The paint settles in the recesses as it dries.

Great effects can be created on large formats if you pour the diluted glaze onto the picture.

WET-IN-WET TECHNIQUE

For the wet-in-wet technique, wet paint is applied onto a wet background. The strongly diluted colours flow freely onto the damp painting surface. Instead of spreading the paint evenly, let it run and 'tease' the transitions by tilting the painting support. The original watercolour technique allows delicate applications of paint, and the uncontrolled flow of paints into each other results in exciting gradations. In wet-in-wet applications on thick textural layers, the paint collects in the recesses of the picture surface, emphasizing their character.

SPLATTER OR SPRAY TECHNIQUE

With this technique, you splatter or spray the paint onto the painting surface to produce splashes, drops or free-flowing spots of glaze. To let the splatters run, simply tilt your painting support medium carefully in the desired direction. Experiment with different tools and techniques to achieve different effects. The following examples of splattering or spraying with a bristle brush, toothbrush and flat brush are just suggestions, and can be enhanced by your imagination as you desire.

Dilute acrylic paint to an aqueous mixture. Dampen the painting surface and apply the solution to it quickly.

Pull back on a loaded bristle brush with your finger – you will get finer or more extensive splashes depending on the liquid content.

Apply the solution quickly to the background. The paint spreads randomly in the dampened space; it 'blossoms'.

Alternatively, use a toothbrush; dip this in the diluted paint and rub over the bristles with a finger.

Tease the paint by turning and tilting the painting support, and spray sharp edges with water if necessary.

Take a flat brush and knock it against your hand or another brush to splatter over larger areas.

GRANULATION TECHNIQUE

Applying undiluted, thick paint with a dry brush and without applying any pressure on a rough background is called granulation technique. It is best to use discarded bristle brushes – the more frayed, the better. The brush must be absolutely dry, as any residual moisture makes the technique impossible. You also need a textured base. Smooth spaces cannot be granulated, as the paint only adheres to raised areas; recesses remain clear as the paint does not flow into them.

LIFTING-OFF TECHNIQUE

For the lifting-off technique, spray water into impasto colour spaces that are not completely dry. As a result, the water 'eats' the pigments out of the freshly wetted areas. After the impasto layer has dried, wipe away the wet splashes with a cloth. This will leave you with random recesses which allow you to see the underlying space. Using this technique is particularly exciting and attractive on high-contrast backgrounds.

Take a small amount of undiluted paint and stipple the brush on the palette. Otherwise, the background will be coated too much.

Stroke the brush in a flat, almost horizontal position over the background, without applying any pressure. The clearer the colour contrast, the more powerful the effect.

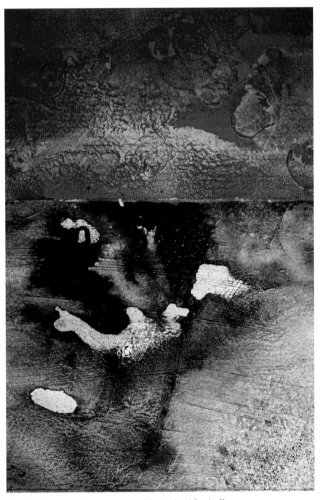

The background becomes visible in the lifted-off areas.

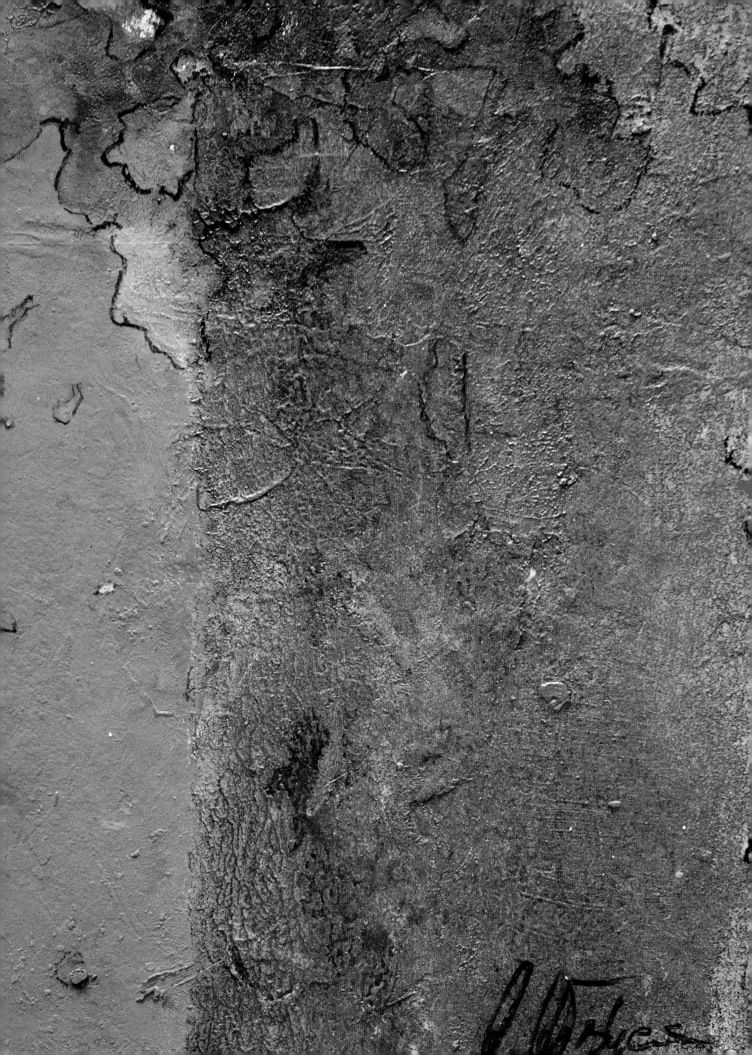

Impasto with a Brush and a Hard Rubber Roller

TASK AND MATERIALS

Focal points

Colour, space, form, outline, paint texture, variation

Equipment

Flat brush, hard rubber roller

Materials

Stretched canvas: 60 x 80cm (23½ x 31½in), charcoal

Acrylic paints: Cyan, Burnt Umber

Original format

INSTRUCTIONS

Brush undiluted cyan over the entire image area in generous motions. Leave brushstrokes as well as thicker applied paint. Once the first coat is dry, use a hard rubber roller to apply Burnt Umber to about two-thirds of the space. In the transitional area, apply only one coat to the first application; in the rest of the space, and after each layer has dried, apply several layers of Burnt Umber on top of each other with the roller to achieve an almost leather-like paint texture. Finally, strike diluted Cyan onto the upper third with the brush. When the painting is completely dry, outline the resulting splashes and spots with fragmented charcoal lines.

TIP

The hard rubber roller can be used to produce a very special surface appearance in several layers, allowing them to dry completely in between.

Interim stage before the charcoal outlining

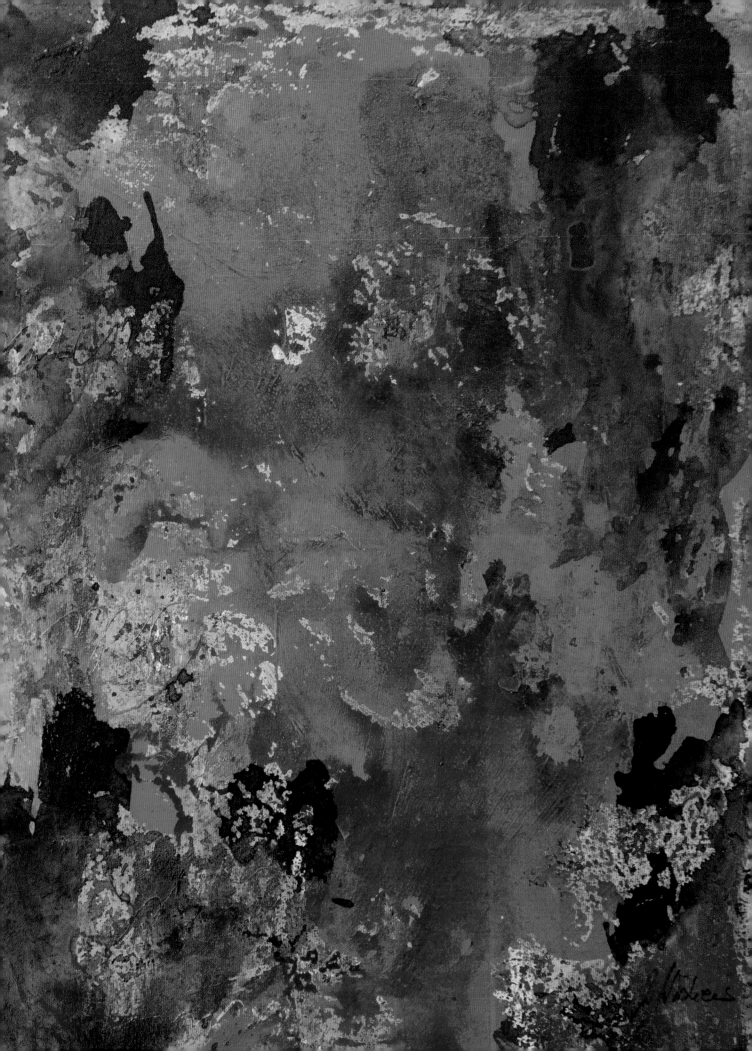

Pouring on Underpainting

TASK AND MATERIALS

Focal points

Colour, space, form, dynamics, variation, contrast

Equipment

Spatula, flat brush, dosing bottle with nozzle, pipette, spray bottle

Material

Stretched canvas: 110 x 150cm (43¼ x 59in)

Acrylic paints: Cadmium Red, Orange, Silver, Indigo, Black

Aero Color: Madder Red Dark

Original format

INSTRUCTIONS

With a spatula, apply Orange and Silver to the dry Black underpainting in a loosely linked arrangement over the entire space, so that the underpainting shines through only in some places. Use undiluted Silver applied with the nozzle of a dosing bottle to write some illegible text in a raised line. Apply Cadmium Red freely to the central area of the picture; granulate the edges out. After they have dried, dilute the Indigo in a bowl into a thin glaze and pour the paint sweepingly over the picture surface from all four corners. Leave the edges of the paint to harden. Then, swipe out the paint residues from the brush onto the picture surface. Finally, using the pipette, apply the Madder Red Dark over the spatula-worked red space and spray the edges with water. Pay attention to the partial overlapping of the individual colour spaces and gaps in the paint application, which allow a view of the lower layers.

TIP

Vibrant red can only be achieved on correspondingly pure underpainting. The luminosity is increased by the final superimposition of the glossy-drying Aero Color.

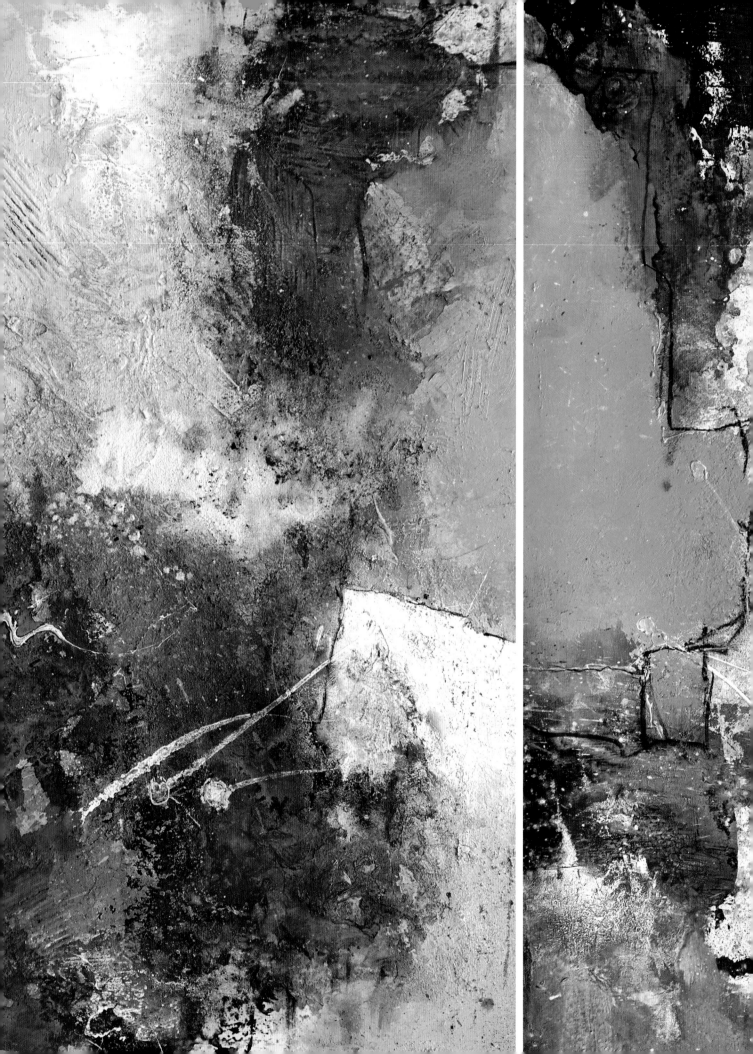

Pouring on Collage and Texture

TASK AND MATERIALS

Focal points

Texture, colour, space, form, line, dynamics, variation, contrast

Equipment

Spatula, flat brush, bowl, spray bottle, dosing bottle

Materials

Stretched canvasses: 80 x 100cm (31½ x 39½in), 40 x 100cm (15¾ x 39½in), light texture paste, ash, tissue paper, corrugated cardboard, charcoal

Acrylic paints: Titanium White, Sand, Vandyke Brown, Pebble Grey, Cobalt Turquoise, Silver

Original format

INSTRUCTIONS

First, partially collage corrugated cardboard and tissue paper. Then, use paste and ash to texture the picture surface, in generous motions. On top of the dry texture, apply an underpainting in Titanium White and Sand. After it has dried, spread Vandyke Brown over large areas with a spatula, dilute the rest of the Vandyke Brown to a thin glaze in a bowl, and pour the paint over the picture surface in a sweeping motion. Trust your intuition; leave edges of the paint to harden, or spray soft transitions with the spray bottle. Finally, swipe out the paint residues on the brush onto the picture surface. Cover other spaces in Cobalt Turquoise with the flat brush and granulate the edges. Now, lighten some areas of the remaining spaces using Titanium White, and swipe three-dimensional, linear traces over the work with the open paint tube. Then, cross-link the surfaces with partial pourings and splashes in Pebble Grey. Using charcoal and a dosing bottle (with undiluted Silver), outline the areas of colour spaces in fragmented lines.

TIP

A diptych stretched over two canvasses of different widths produces a certain dynamism. Link the canvasses at the transition points between them.

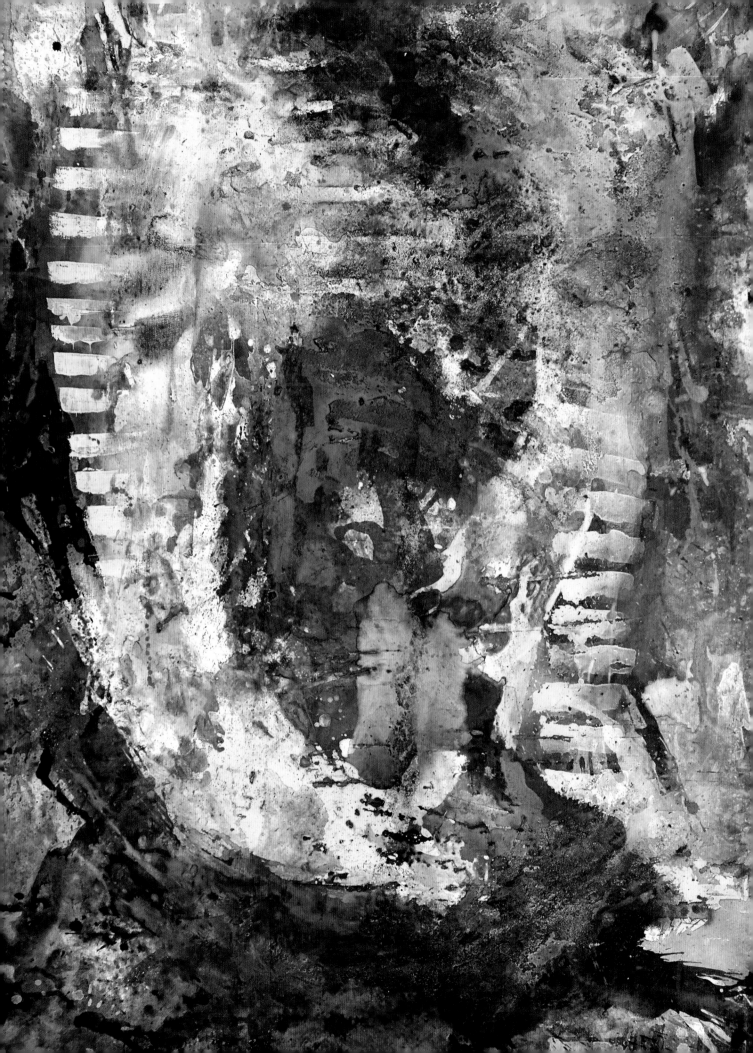

Pouring on Texture

TASK AND MATERIALS

Focal points

Colour, space, form, dynamics, variation, contrast

Equipment

Flat brush, spray bottle, bowl

Materials

Stretched canvas: 120 x 150cm (47¼ x 59in), light texture paste, ash, wood shavings

Acrylic paints: Titanium White, Black, Green Earth, Yellow Ochre, Burnt Sienna, Brilliant Violet

Original format

INSTRUCTIONS

Use paste, ash, and wood shavings to texture the space, in generous movements. On top of the dry texture, apply an opaque underpainting of Yellow Ochre. After drying, dilute Burnt Sienna in a bowl to a thin glaze and pour the paint sweepingly over the picture surface. Trust your intuition; leave edges of the paint to harden or spray soft transitions with the spray bottle. Finally, swipe the paint residues on the brush over the picture surface. After the first pouring has dried, continue in the same way with Green Earth. In a third step, do likewise with a creamy mixture in Black. After drying again, paint rectangular strips in Titanium White. For the final step, glaze with a partial pouring of Brilliant Violet. Pay attention to partial overlapping of the individual colour spaces, and to gaps in the colour application which allow a view of the lower layers.

TIP

Generous pouring is really fun on large formats. It is best to work outdoors, so that you can pour over the picture support without any constraints.

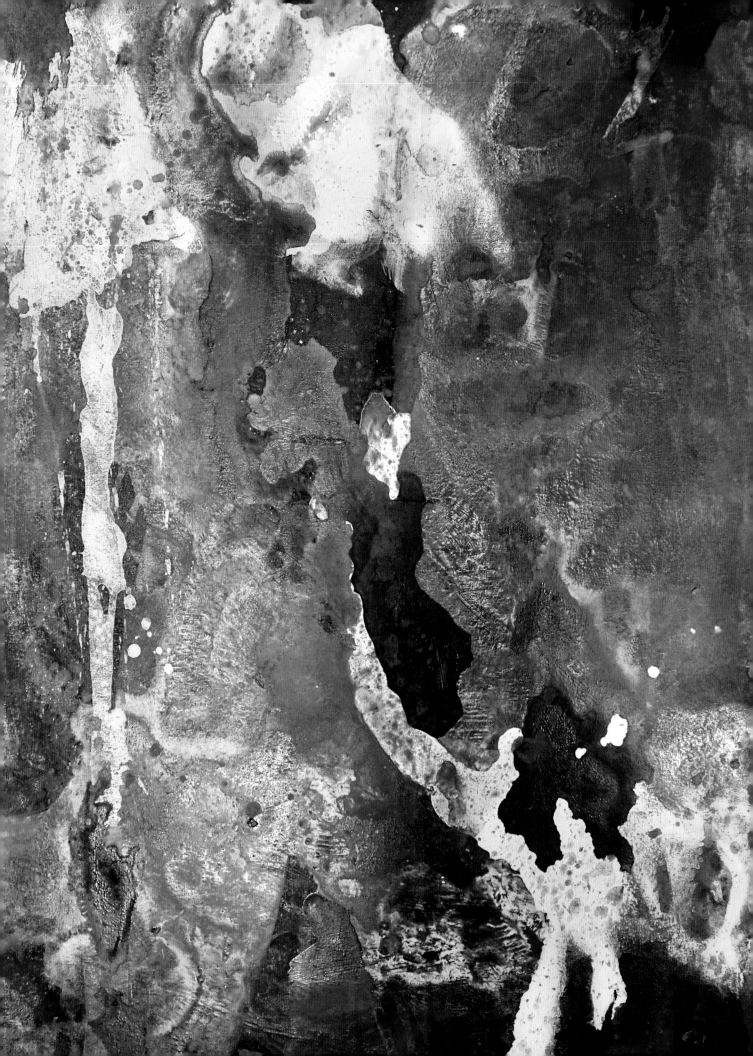

Pouring on Opaque Underpainting

TASK AND MATERIALS

Focal points

Colour, space, free form, dynamics, variation, contrast

Equipment

Spatula, spray bottle, bowl

Material

Stretched canvas: 60 x 100cm (23½ x 39½in)

Acrylic paints: Caput Mortuum, Titanium White, Black, Green Earth

Original format

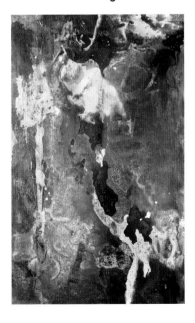

INSTRUCTIONS

Apply an opaque underpainting to the canvas using a spatula in Caput Mortuum. After it has dried, dilute the Black in a bowl to a creamy glaze, and pour the paint sweepingly over the picture surface. Trust your intuition; leave edges of the paint to harden, or spray soft transitions with the spray bottle. Finally, knock out the paint residues on the brush onto the picture surface. After the first pouring has dried, continue in the same way with Titanium White. In a third step, do likewise with Green Earth. Leave gaps in the layer of applied paint and ensure partial overlapping of the individual pourings.

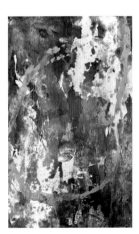

This version was built up in similar steps but using other shades. The final blue colour traces are almost floating on top of the lower layers.

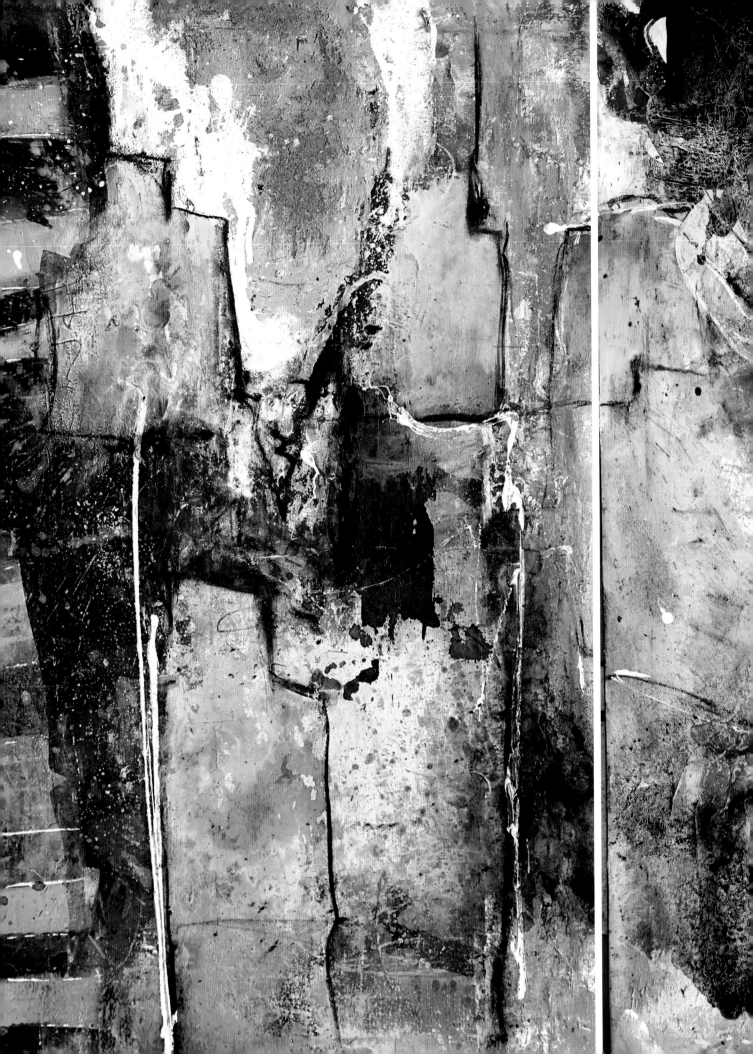

Glaze and Impasto on Texture

TASK AND MATERIALS

Focal points

Space, line, pattern, dynamics, variation, contrast

Equipment

Pencil, pipette, spatula, flat brush, spray bottle, dosing bottle

Materials

Stretched canvasses: 80 x 100cm (31½ x 39½in), 40 x 100cm (15¾ x 39½in), light texture paste, ash, charcoal

Acrylic paints: Titanium White, Pebble Grey, Naples Yellow, Black

Aero Colors: Brown Brazil, Golden Ochre, Primary Blue Cyan, Violet, Supra White

Original format

INSTRUCTIONS

Use the pencil to engrave some scribbles freely into a textural application in the central area. Follow this with various glazes in Brown Brazil, Cyan, and Violet; use a pipette to apply each colour in lines and splotches and spray the edges with water. Use the spatula to create a strip of rectangles, similar to a zebra crossing, in Pebble Grey. Use the pipette freely to draw traces of movement, repeating ovals and outlining the spatula-worked stripes in Supra White. Partial pourings follow in the following order: Pebble Grey, Naples Yellow. and Black. The paint residues are knocked out onto the picture surface with the brush. To calm some areas, cover them with texture paste and ash. Then, lighten some areas of the remaining spaces in Titanium White and make raised, linear traces over the work with the open paint tube. Finally, combine the larger spaces with charcoal outlines.

TIP

In addition to the vertical band of rectangles, the picture is dominated by the linked spaces in striking shades of yellow.

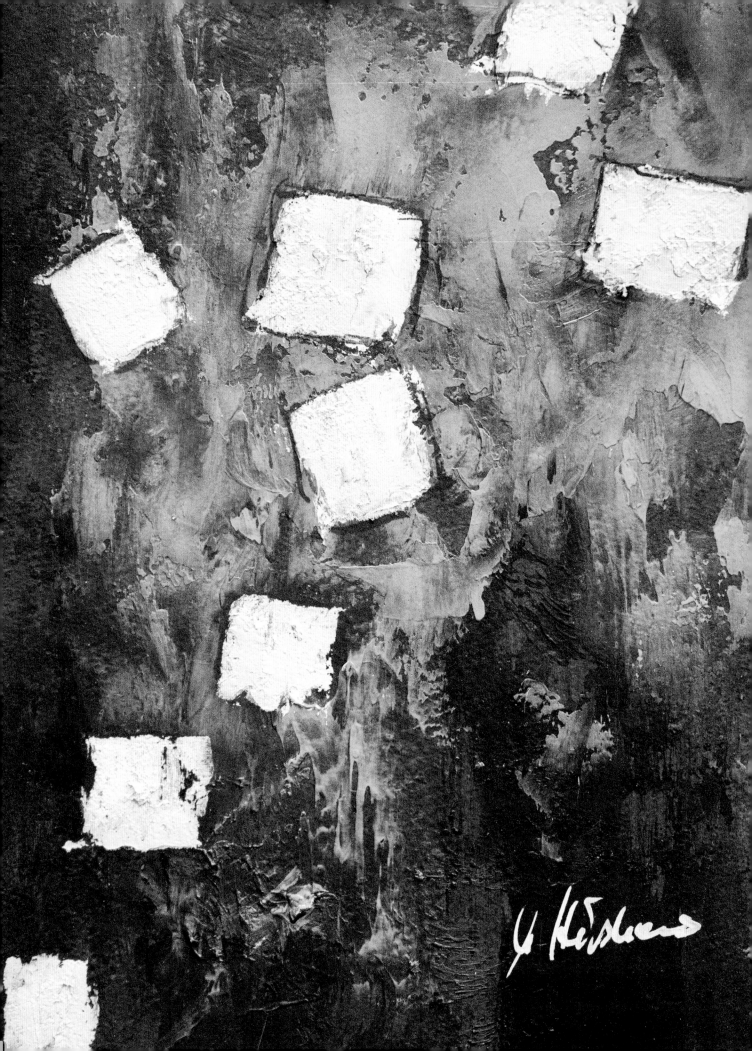

Impasto with a Spatula on a Glazed Underpainting

TASK AND MATERIALS

Focal points

Colour, space, form, dynamics, variation, contrast, motion

Equipment

Spatula, flat brush

Materials

Stretched canvas: 60 x 90cm (23½ x 35½in), charcoal

Acrylic paints: Alizarin Crimson, Vandyke Brown, Green Yellow, Silver

Original format

INSTRUCTIONS

Apply fragments of Vandyke Brown to a glazed underpainting in Alizarin Crimson. Leave clear gaps in order to keep the view of the underpainting free. Starting at the upper-right Golden Intersection, apply Green Yellow with a spatula. Stripe the paint around the edges in a granulating manner. Create Silver squares with the spatula, as if silver tiles were falling from the sky. The outlines of the squares in the lighter areas of the picture can then be emphasized with charcoal.

Interim stage

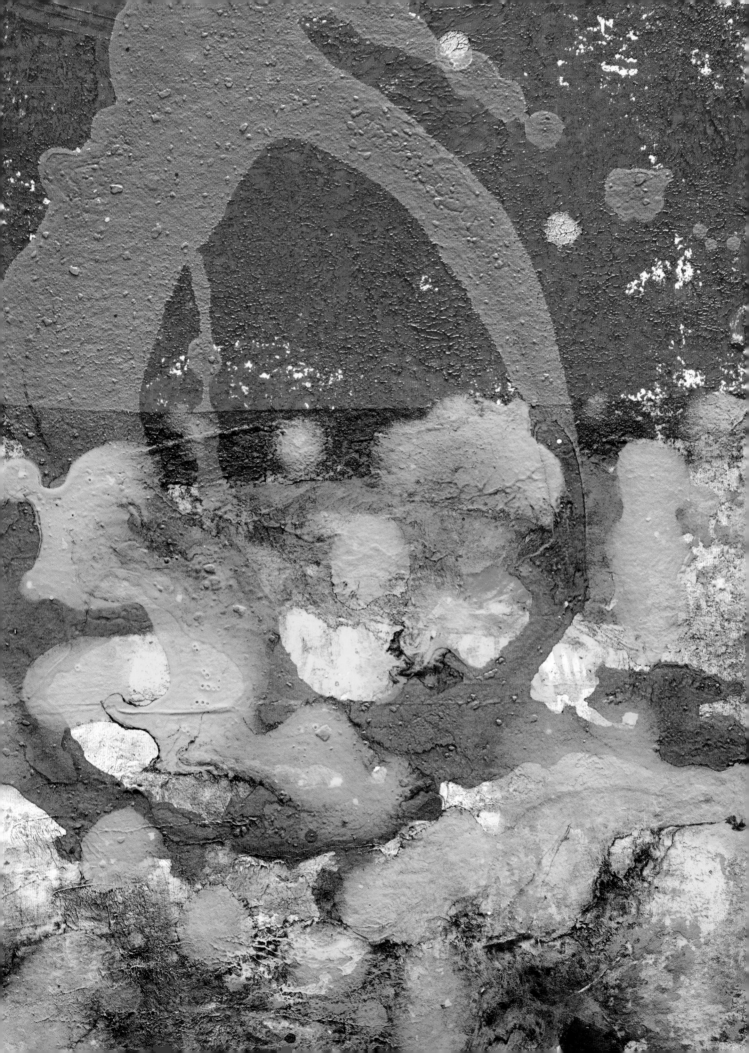

Rolled Textural Application

TASK AND MATERIALS

Focal points

Colour, space, form, dynamics, variation, contrast

Equipment

Spatula, flat brush, hard rubber roller, dosing bottle

Material

Stretched canvas: 50 x 80cm (19¾ x 31½in), newspaper

Acrylic paints: Primary Yellow, Primary Cyan, May Green, Madder Red Deep, Vandyke Brown

Original format

INSTRUCTIONS

The lower half of the picture contains an underpainting made with the spatula and leftovers of Yellow and May Green. Onto the remaining empty space – a little more than a third – roll several layers of Madder Red Deep with the rubber roller, letting it dry in between layers in order to achieve an almost leather-like paint texture. Fill a dosing bottle with slightly diluted Cyan, and, in a sweeping movement, paint an oval line over both areas. Splashes and streaks of paint will enliven your work. Glaze about two-thirds of the picture with Vandyke Brown. Finally, cover the upper third with newspaper and daub on a mixture of diluted Yellow and May Green with a brush. The effect of the dominant red space is reduced by the calm texture created by the hard rubber roller. The streak of blue and the loose splashes of Green Yellow provide a bold contrast.

Interim stage

LINE

Lines are artificial constructs that were originally invented to be able to create messages in the form of pictograms (Latin/Greek = written image). The forerunners of Asian writing systems, for instance, were symbols conveying information by simplified graphic representation, consisting of juxtaposed lines.

THE ART OF DRAWING LINES

In the age of abstract art, the line acquired the ability to express something without necessarily representing anything in particular. Phrases such as 'soft and gentle', 'lively', 'flowing' or 'in rapid sweeping movements' became increasingly important. Lines are traces of motion; in addition to the soft, curving line, there is also the sharp-edged, angular line, or the rigid, straight line. A line can be delicate, trembling, erratic, edgy and unsure of itself, or it can be rough, brutal and brimming with confidence, just as decreasing or increasing the pressure causes massive changes in the expressiveness of your stroke. Drawing lines in a spontaneous and expressive way where possible is essential in abstract painting.

We perceive a broad line as a space with two outer contours.

Even a thin line has a contour on both sides.

PRACTICE

The spontaneity required for vivid drawing can only result from experience and familiarity with the technique. Discover your own style by comparing lines in dual pairings for the purposes of study. In this way you will discover the multitude of possible ways in which your hand can move on the drawing support medium. A certain dexterity in using all common application techniques, as well as skilfully combining them, will develop over time.

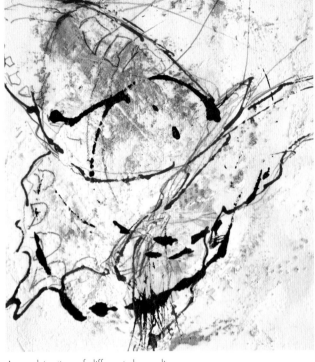

A combination of different drawn lines.

Pictograms are composed of thin, thick and accentuated lines.

straight — wavy

dashed — dotted

jagged — looped

continuous — fragmented

Drawing is purely a matter of practice. Use relaxation exercises to warm up your hand, and 'train' it daily. Take every opportunity to draw: on the phone, on the train or in the waiting room.

- Do not lay your arm on the table while drawing.
- Work in generous motions, perhaps even standing up.
- Draw with full physical exertion and use the full extent of your wrist as well as that of your elbow and shoulder joint.
- Also draw with your eyes closed.
- Draw quickly – put yourself under time pressure.

Illegible handwriting

Spirally interwoven

Sweeping curves

Repeated signatures

Ant scribbles

Curved hatching

EXERCISES

- Your personal handwriting identifies you and is unique. Just as if you were writing something down in your sloppiest handwriting, you also draw the same familiar lines in your pictures. It should be illegible in order to do justice to abstraction.

- Your personal style of drawing lines is reflected in your personal or everyday signature. Create a design for the entire picture surface out of the repetition of your name. Overlay the individual signatures to create a veritable web of lines.

- Free lines are created by the expression of feelings or playful thoughts. Imagine, for example, that you are alone on a frozen lake and can skate laps to your heart's content. Try out sweeping pirouettes and triple jumps, and let yourself go…

- Imagine walking across the picture as an ant. Without applying any pressure (an ant has no perceptible weight), scribble your way through your picture, guided by the obstacles on the surface. Increase the pressure (an ant can carry many times its own body weight) and continue scribbling strongly. Do not put your pen down but stay on the surface (an ant can neither jump nor fly). No matter where you want to get to, you have to make your way with the pen.

- Now fly and hop like a sparrow and leave the surface in between. This creates fragmented lines. These do not delineate; no interior forms are created.

Nature is adept in using the most diverse lines to animate spaces. In the details, you will find many suggestions, both tactile and protruding or deeply engraved.

FUNCTIONALITY

Lines perform certain functions, no matter what type of lines you draw.

VARIATIONS

- Outline – Separates a space from the rest of the picture and gives it an internal form.
- Separation line – Separates spaces without framing them, the best example being a horizontal line that runs across the entire picture surface.
- Supporting line – The edges of resulting colour spaces are carefully picked up and emphasized with minimal use. This creates an effect of spatial separation, and thus of more visual depth.
- Disruptive line – A powerfully set line or scribble or a destructive scribble that conveys a feeling of rage and disturbs or breaks up the picture area to a certain extent.
- Connecting line – Joins elements together, creates connections, and links the picture surface together.

Woodworm tracks

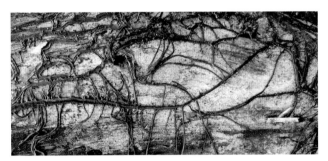

Lichen

Dry branches

Moss

Connecting line

Separation line

TACTILITY

Compared with a flat, non-elevated line, such as a pencil drawing, a raised line can produce completely different effects.

VARIATIONS

- You can achieve a tactile effect by engraving into thick applications of paint or texture, by scratching deeply into it.
- In contrast to an engraved line, a three-dimensional, raised line lies on top of the existing background.
- Twine arranged and then concealed under collage paper has a rather subliminal effect.

SGRAFFITO

You can achieve a tactile effect by engraving in thick, impasto layers, scratching deeply into them in order to bring out the original painting surface or the underlying colour. You can achieve different effects depending on the tool you use.

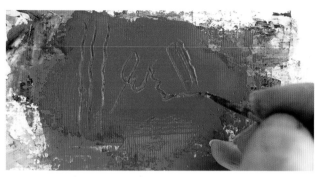

Engrave your desired lines or shapes into the damp layer.

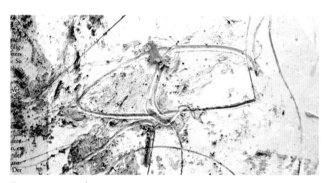

Engraving in a damp texture

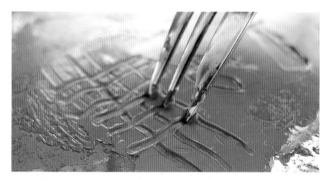

For perforated stripes or grid effects, use a fork.

Twine under Chinese paper

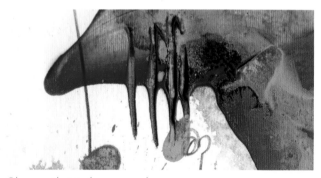

Glazes settle into the engraved grooves.

EXTRUSION TECHNIQUE

In the extrusion technique, pastose paint or texture paste is pressed through a pointed nozzle. This creates a strong line with a tactile relief effect. The thickness of the line can be varied by reducing or increasing the pressure on the container.

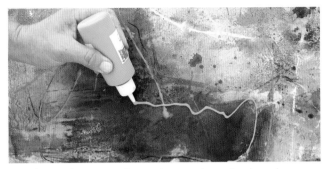

In order to obtain even lines, draw a plastic bottle with a pointed nozzle over the image carrier medium at a constant speed.

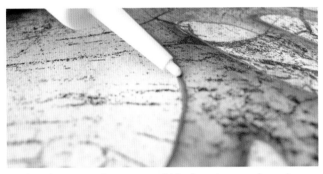

This line drawing technique is useful for free drawing, for outlining shapes, and for delimiting different spaces.

Outlines in pencil

Tools and materials

You need a variety of engraving tools, pipettes, bottles with pointed nozzles, nibs and different pens or dry media like chalk or charcoal. If you have reworked a picture with non-adhesive media such as charcoal or soft pastel, you should spray it with fixative afterwards, to stop the marks from 'chalking away' when touched.

- Charcoal can be used to emphasize and define the outlines of a drawing. Fragmented outlines consolidate forms without enclosing them.

- Graphite sticks and pencils are ideal for destructive scribbles on dry surfaces as well as for engravings in damp, pastose paint or textural applications.

- Oil pastel creates thick, full or granulating lines depending on the pressure applied; if you glaze over it with acrylic paint, it will roll off the oil pastel.

- Soft pastel is suitable for delicate, finishing line work. Drawn flat over the background, the pastel sticks leave wide granulating traces.

- Coloured pencils are ideal for the final revision of acrylic paintings. Fragmented outlines strengthen the contours.

- Use drawing pens of different widths or an Asian reed pen, which can be very fine or thick, depending on whether it is angled for ink, Indian ink or liquid acrylic paint.

- Use pipettes for liquid paint. Plastic bottles with pointed nozzles can be filled with pastose paint.

- Pastose paint is stamped on in graphic lines using the narrow edge of a piece of cardboard or a spatula.

- Engrave lines using etching needles, toothpicks, knitting needles, the back of a brush handle, or special colour shapers.

- Patterns can be created with a fork, a comb, or a notched tiling trowel from a DIY store.

Granulated line work with soft pastel

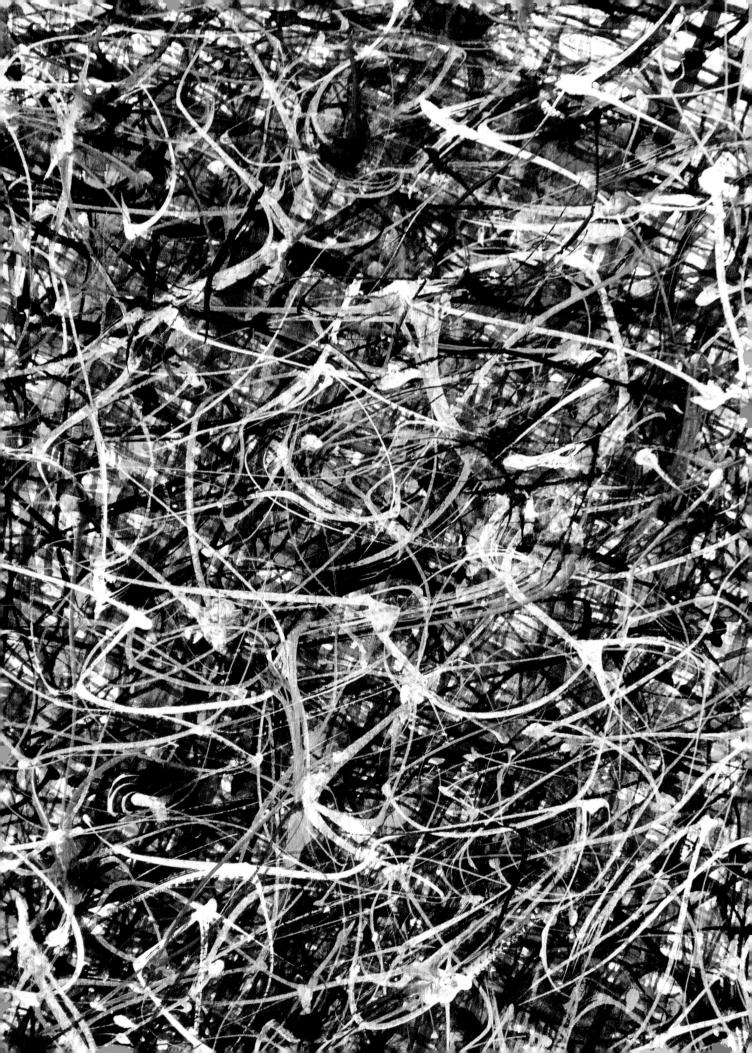

Linear Overlays

TASK AND MATERIALS

Focal points

Line, motion, dynamics, variation, contrast, overlaying, consolidation

Equipment

Pots, round brush, size 4–6

Material

450gsm acrylic paper, 30 x 50cm (11¾ x 19¾in)

Acrylic paints: Titanium White, Primary Yellow, Cadmium Red, Primary Cyan, Sap Green, Black

Original format

INSTRUCTIONS

Dilute all the acrylic paints in advance in separate pots. With a thin round brush, take up the first colour and scribble criss-cross streaks across the picture surface. Start with one of the brighter, stronger colours (e.g. Cadmium Red), and let each layer dry before moving onto the next colour. The last trace, in Titanium White, lies like a net over the layers underneath. The linear consolidation through the multiple overlays creates immense depth in the picture.

Variation scribbled in a vertical alignment

Variation with round, sweeping loops

TIP

This meditative way of working is ideal training for freer brushwork, and also loosens your hand.

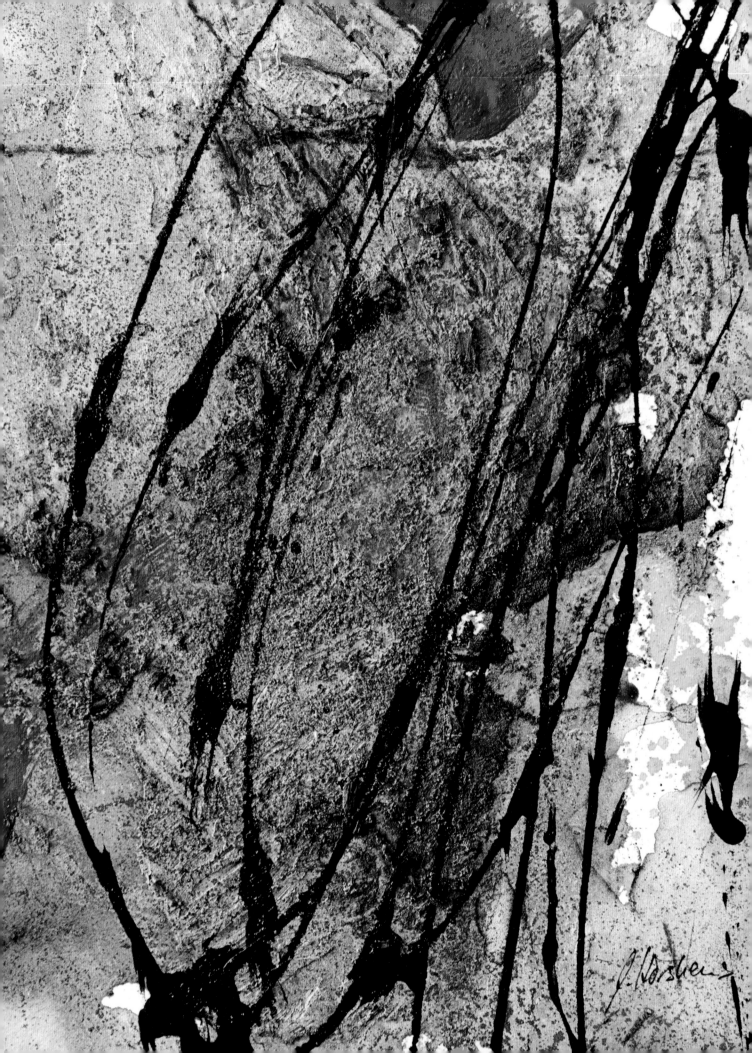

Splattered Line on Collage

TASK AND MATERIALS

Focal points

Colour, space, line, texture, variation, dynamics, motion, contrast

Equipment

Spatula, flat brush, pipette

Materials

Stretched canvas: 40 x 50cm (15¾ x 19¾in), light texture paste, silica sand, wood shavings, tissue paper

Acrylic paints: Cadmium Red, Burnt Sienna, Green Earth

Aero Color: Black

Original format

INSTRUCTIONS

On a tissue paper collage (visible in the upper third), apply texture paste with a little silica sand and occasional wood shavings, using sweeping traces of motion. Glaze first Cadmium Red, then Burnt Sienna onto the central area of the upper two-thirds with the flat brush, in a broad oval shape, and knock the paint residues onto the picture with the brush. For the third glaze, mix Burnt Sienna with some Green Earth. Finally, use the pipette to draw Black Aero Color paint onto the dry surface in oval, linear traces. Do not let the size of the canvas restrict your energy. Go beyond the edge of the canvas with the glazes and the drawing, so that truncated shapes and lines are created. Do not improve anything – some areas of the image that are not immediately covered remain untreated.

TIP

Spontaneity and dynamics give life to this picture. Don't hold back – give your energy free rein! If it does not work, use the painting support medium for a new motif. You can fall back upon this valuable underpainting.

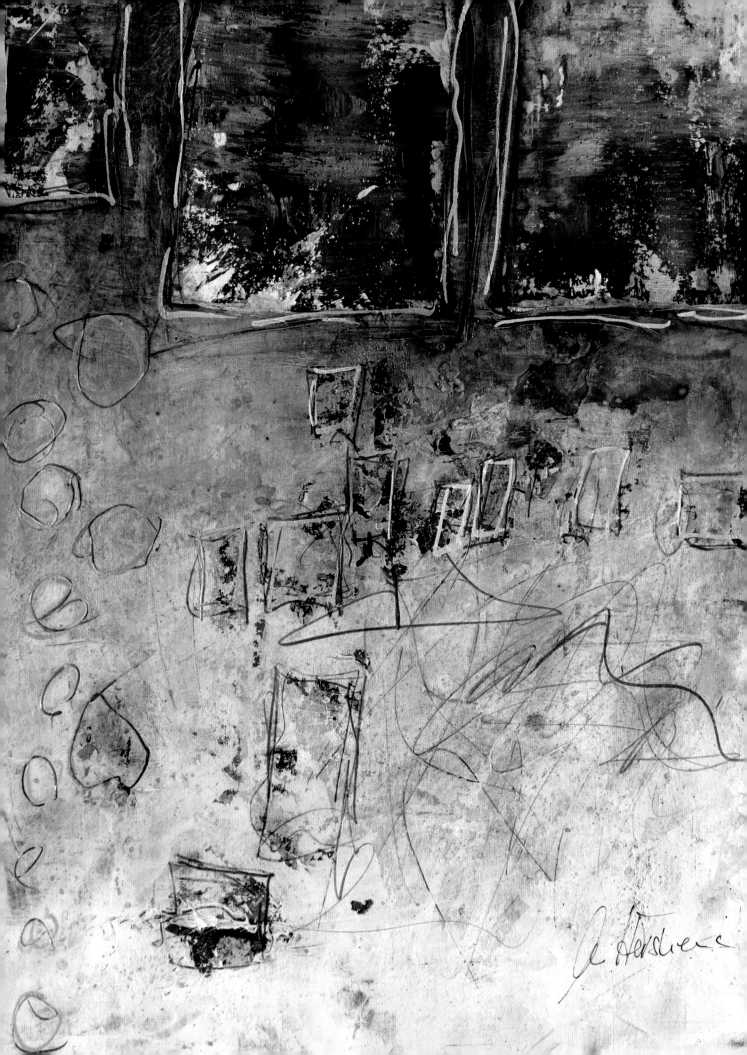

Shining Silver Contours

TASK AND MATERIALS

Focal points

Colour, space, line, form, dynamics, contrast, harmony

Equipment

Spatula, flat brush, pencil

Material

Stretched canvas: 40 x 60cm (15¾ x 23½in)

Acrylic paints: Titanium White, Sand, Pebble Grey, Vandyke Brown

Acrylic marker: Silver

Original format

INSTRUCTIONS

Apply Sand and Vandyke Brown directly from the tube to the entire painting support medium, and blend the two colours into each other using the spatula. With the exception of three rectangular windows and a few intuitively retained blank spaces which provide a view of the background, the space will now be gradually covered. Start with Pebble Grey and repeat the process with Sand and Titanium White. Apply the above colours alternately with the flat brush (either partially opaque, transparent or granulating) until you are satisfied with the space. Pencil scribbles (ranging from very delicate, barely perceptible lines to powerful, deep engravings in wet paint) lead through the picture in the manner of a narrative. Finally, make a spontaneous outline around the three rectangular windows, the different patches of colour, and a few round curls using a Silver acrylic marker.

Interim stage

TIP

In each intermediate step, draw on dry areas with the pencil, and engrave into the paint spaces that are still damp.

Charcoal Drawing on Rolled Paint

TASK AND MATERIALS

Focal points

Space, line, form, motion, dynamics, variation, contrast

Equipment

Hard rubber roller, flat brush, spray bottle

Materials

2 stretched canvasses: 30 x 70cm (11¾ x 27½in), charcoal, Green soft pastel

Acrylic paints: Burnt Sienna, Copper, Primary Cyan

Original format

INSTRUCTIONS

Perform variations of each of the following steps on both canvasses simultaneously. First, apply undiluted Burnt Sienna by criss-crossing over a large part of the surface with the roller. After applying a glaze over the entire picture surface (also with Burnt Sienna), repeat this with Copper. Pour diluted Cyan freely onto the central area of the picture, and spray some of the edges of paint with water to create soft transitions. Use charcoal to outline the poured form in subtle, fragmented contours. In a corner which has been left free, disturb the harmony with powerful, aggressive charcoal scribbles. Finally, add another colour highlight by filling in the small interior forms created by the scribbles with green soft pastel.

TIP

Paint spaces that are applied with a hard rubber roller exhibit a special surface appearance.

Detail of filled-in interior form

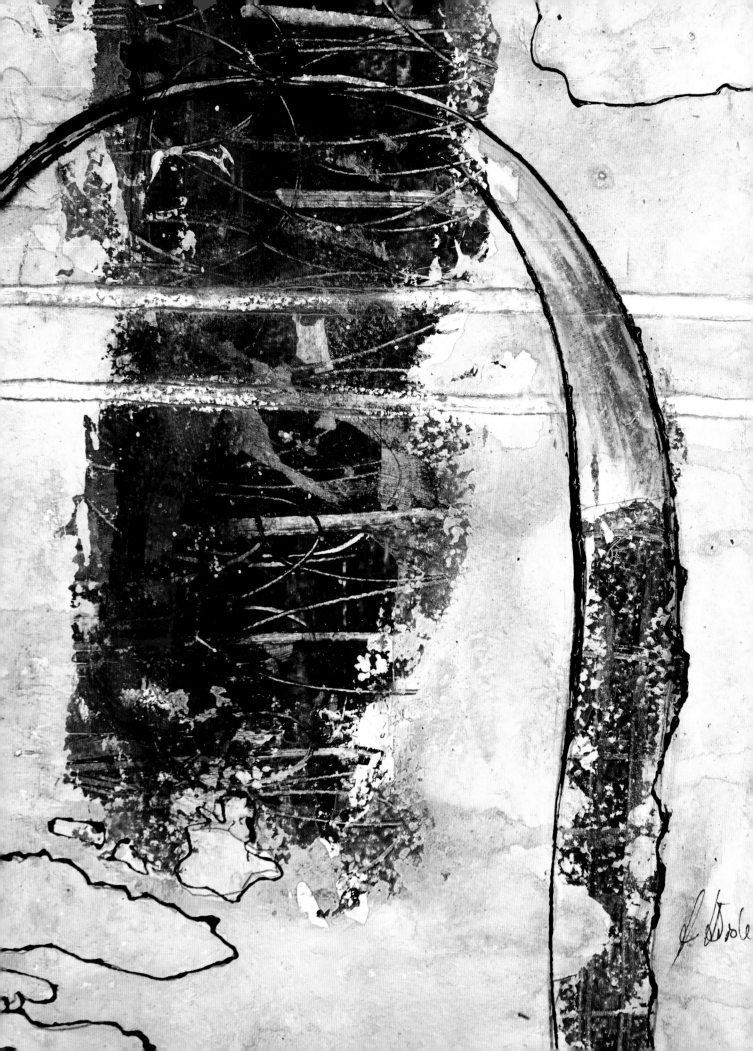

Combining Engraving and Tactility

TASK AND MATERIALS

Focal points

Colour, space, line, dynamics, motion, contrast, harmony

Equipment

Spatula, pencil, colour shaper, dosing bottle

Material

Stretched canvas: 40 x 60cm (15¾ x 23½in)

Acrylic paints: Naples Yellow, May Green, Primary Cyan, Pebble Grey, Green Earth, Alizarin Crimson, Black

Oil pastel: White

Original format

INSTRUCTIONS

Onto some partially painted-on paint residues in Naples Yellow, May Green and Cyan, use a spatula to apply a wide block and a narrow strip of Alizarin Crimson. Use the colour shaper to scrape wide stripes into the damp paint and engrave curling oval lines that extend beyond the area of applied paint. With the spatula, cover the background entirely in Pebble Grey and granulate the edges of the paint into the parts of the surface left blank. Glaze the background with very diluted Green Earth. Extend two of the scraped-out lines on the surface with a pencil across the entire width of the picture (in the area around the upper third horizontal line) and fill them in with White oil pastel. Using slightly diluted Black in a dosing bottle with a thin nozzle, draw on one of the oval curves on the background and use these lines to link the second colour space left blank. Accentuate some of the resulting edges of glaze in the same way with subtle outlines.

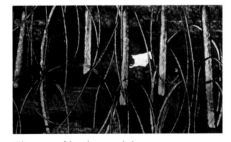

Close-up of background design

TIP

The Green Earth glaze creates a concrete-like effect in the background space.

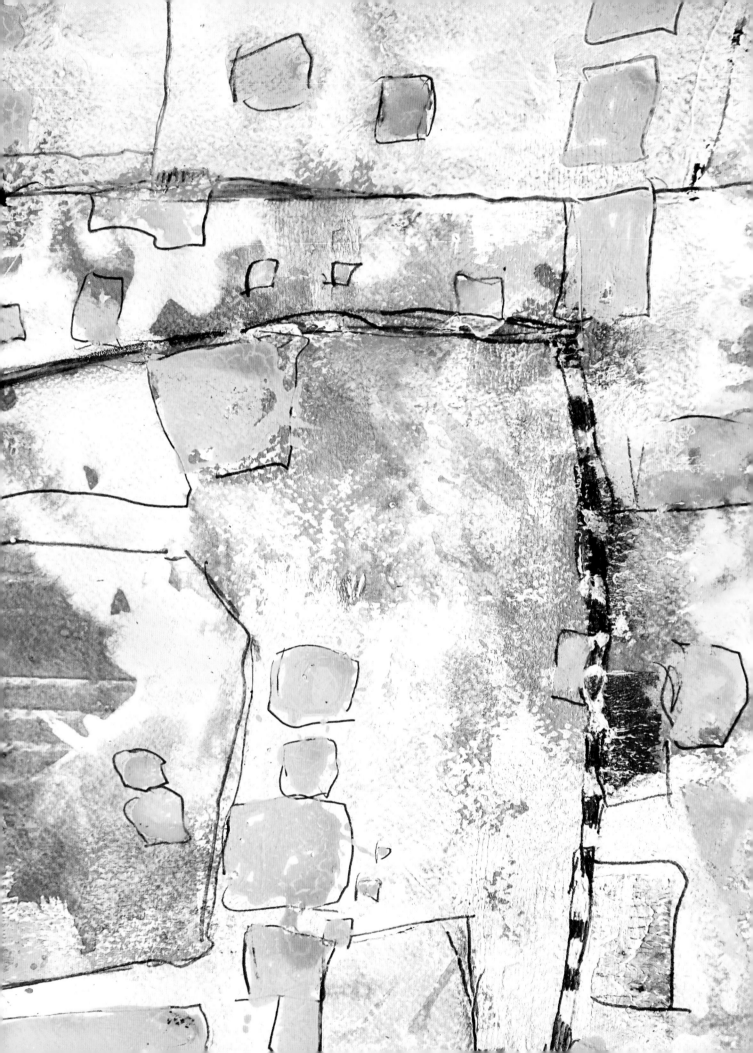

Stylized Pencil Drawing

TASK AND MATERIALS

Focal points

Colour, space, line, form, dynamics, motion, repetition, rhythm, variation

Equipment

Bowl, flat brush, pencil, hard rubber roller, colour shaper, spray bottle

Material

Stretched canvas: 40 x 60cm (15¾ x 23½in)

Acrylic paints: Green Yellow, English Red, Green Earth

Aero Colors: Supra White, Indian Yellow

Oil pastel: Hooker's Green

Original format

INSTRUCTIONS

Roll a few traces in Green Yellow and a strip of rectangular stripes in English Red onto the line of the right-hand third using the hard rubber roller. Dilute Green Earth in a bowl and pour on two large, truncated shapes on the left and right edges of the picture. Scrape horizontal stripes into the wet paint with the colour shaper. Using the flat brush, glaze Supra White over most of the surface, and tease the paint by turning and flipping the painting support. Apply Indian Yellow using the pipette of the Aero Color bottle, and spray the individual edges with water. Scribble occasional lines using the Hooker's Green oil pastel. Then, outline the yellow patches with loose pencil edges. Finally, let yourself be guided by the existing paint textures, and decorate the picture area with drawings and individual hatchings.

Interim stage

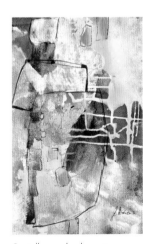

Serially worked version

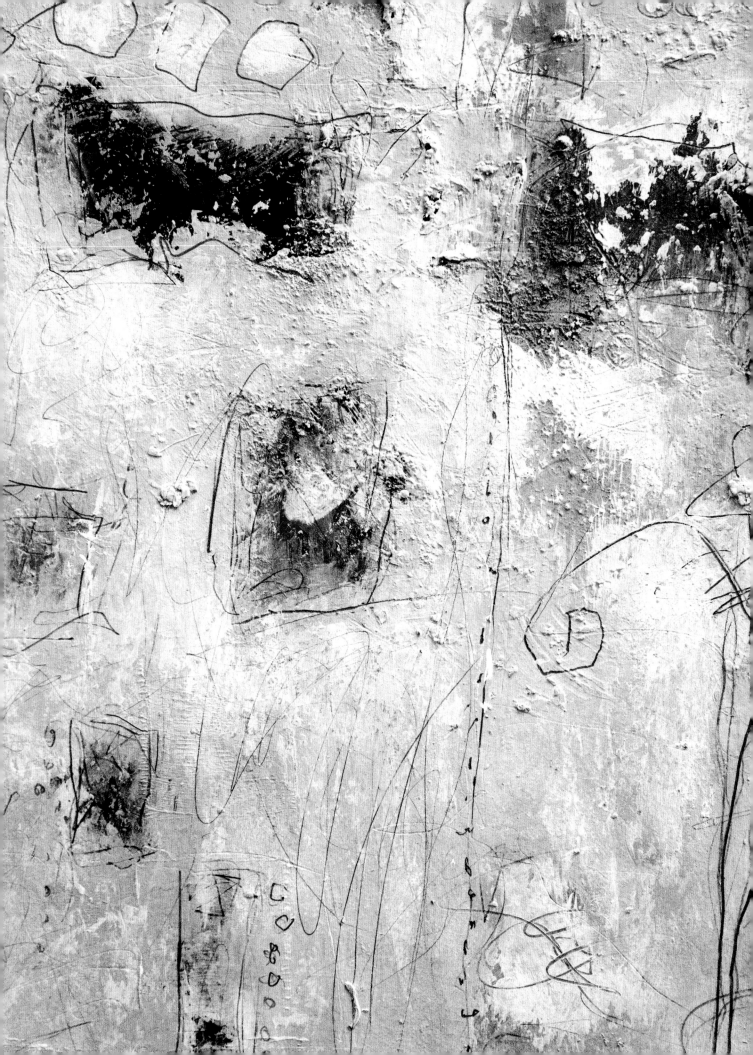

Narrative Pencil Scribblings

TASK AND MATERIALS

Focal points

Texture, colour, space, line, form, contrast, harmony, dynamics, rhythm, variation

Equipment

Spatula, flat brush, pencil

Materials

Stretched canvas: 40 x 60cm (15¾ x 23½in), light texture paste, silica sand

Acrylic paints: Titanium White, Sand, Pebble Grey, Alizarin Crimson, Cobalt Turquoise, Primary Cyan, Black

Original format

INSTRUCTIONS

In the upper third of the picture, use the spatula to create fragmented textures running downward with paste and silica sand. Using the flat brush, paint patches over the entire surface of the picture in a loose sequence of Primary Cyan, Alizarin Crimson and Cobalt Turquoise. In order to link the patches of colour, pour slightly diluted Black over about one-third of the surface (split into two or three areas), and swipe out the paint residues onto the picture with a brush. With the exception of a few intuitively retained blank spaces, which provide a view of the background, the space is now gradually covered. Starting with Pebble Grey, repeat the process with Sand and Titanium White. Apply the above colours alternately with the flat brush, so that they are either partially opaque, transparent or granulating, until you are satisfied with the space. In each intermediate step, draw with the pencil on dry areas, and engrave into colour spaces that are still damp.

TIP

We are led through the painting in the manner of a narrative by the pencil scribbles, ranging from very delicate, barely perceptible lines to powerful, deep engraving into wet paint.

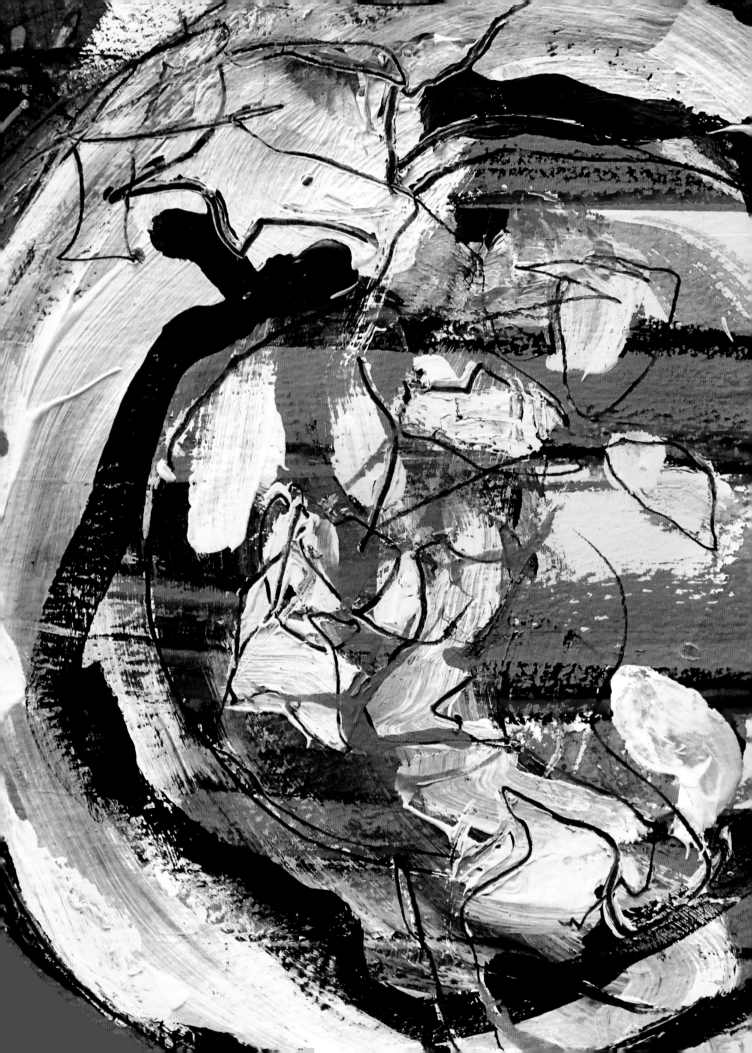

Block Stripes versus Free Line

TASK AND MATERIALS

Focal points

Colour, space, line, form, dynamics, motion, contrast, dominance, opposition

Equipment

Spatula, flat brush, size 10 round brush, dosing bottle

Material

Stretched canvas: 40 x 40cm (15¾ x 15¾in)

Acrylic paints: Titanium White, Sand, Primary Magenta, Golden Ochre, Black

Oil pastels: Black, Dark Red

Felt pen: Black

Original format

TIP

Play with picture elements, stripes and shapes in a similar sequence.

INSTRUCTIONS

Create a wide, free trace of Golden Ochre using the flat brush. Using a mixture of Titanium White and Magenta, paint horizontal block stripes of equal width over the entire picture surface. Do this by drawing the flat brush dynamically across the entire width; without touching up the paint, the opaque and granulating elements remain. Use oil pastel to reinforce the outlines of the block stripes with spontaneous lines in Dark Red and Black. Now use the flat brush to draw a large form and smaller splotches in one go (here, some pumpkin slices with seeds) with a mixture of Sand and Titanium White. With the round brush, go over the large form in Black acrylic paint. Engrave over the motif again by drawing in the still-damp paint with the black felt pen. Make sure to work spontaneously and dynamically – it is not about reproducing a motif neatly and in detail.

Template: Sketch of a pumpkin slice with seeds

Variation with a wide block stripe

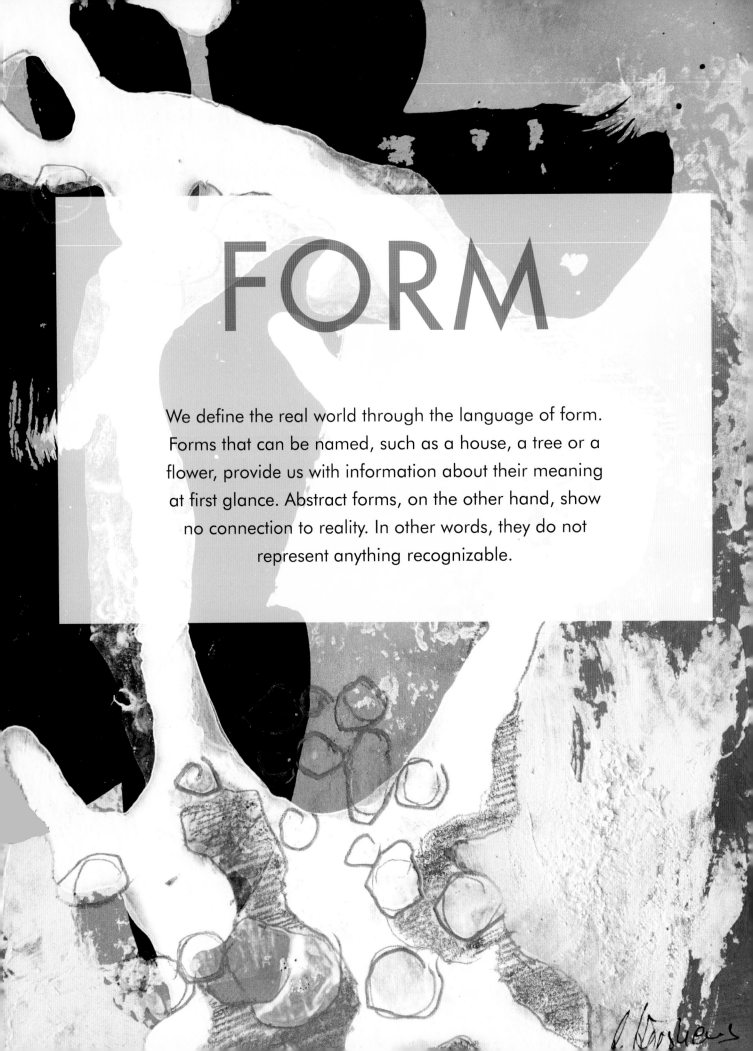

FORM

We define the real world through the language of form. Forms that can be named, such as a house, a tree or a flower, provide us with information about their meaning at first glance. Abstract forms, on the other hand, show no connection to reality. In other words, they do not represent anything recognizable.

DEFINITION OF TERMS

Cubism (meaning the return of real objects to their basic geometric forms) was a term coined by the art critic Vauxcelles (Latin: *cubus* = cube). Based on Paul Cèzanne's thesis that 'everything in nature takes its form from the sphere, the cone and the cylinder', Cubism was one of the intermediate steps between representational and abstract art. The pictorial motif was no longer the subject, but only an impetus for painting. Colour, form and space took on a life of their own. Tachisme or Art Informel (French: *la tache* = splotch; *informel* = formless), which developed as organized structure of form; free forms do not arise from the abstraction of a real object, but from spontaneous rhythms.

We either paint splotches that develop into a form from within, or outline a form with a closed line. This so-called outline encloses a form and separates it from the rest of the picture area.

VARIATIONS

- Geometrical forms such as the circle, square, rectangle and triangle bring calm and a certain order to your picture.
- Organic forms are free forms, which are also found in nature, such as stones or clouds. They are taken out of context and used abstractly.
- Free forms are non-figurative, variable forms that are created in a spontaneous, expressive painting process.

Types of opposing characteristics:

- Small – Large
- Narrow – Wide
- Short – Long
- Light – Dark
- Smooth – Textured
- Opaque – Transparent
- Open – Closed
- Single – Overlappings.

Combination of outlines and splotches

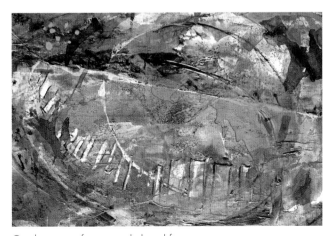

Combination of open and closed forms

Small – Large

Open – Closed

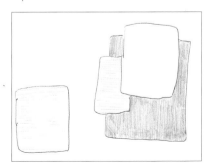

Single – Overlapping

Overlapping Free Forms

TASK AND MATERIALS

Focal points

Colour, form, pattern, variation, contrast

Equipment

Flat brush, pots

Material

Stretched canvas: 30 x 50cm (11¾ x 19¾in)

Acrylic paints: Yellow Ochre, Raw Sienna, Cyan

Original format

INSTRUCTIONS

Dilute the paints in advance into watery glazes in individual pots. Starting with Yellow Ochre, apply the first layer of splotches. To do this, press the filled flat brush repeatedly in spontaneous movements onto the canvas. Choose a different colour for each layer, and play with different intensities and forms. Over time, the multiple overlaying of the transparent glaze splotches will create an immense visual depth. This almost meditative game consisting of applying free forms challenges the spirit. It is not so easy to keep coming up with new variations.

Begin with a light colour, like the Yellow Ochre used here.

Alternative colour tone in related colours

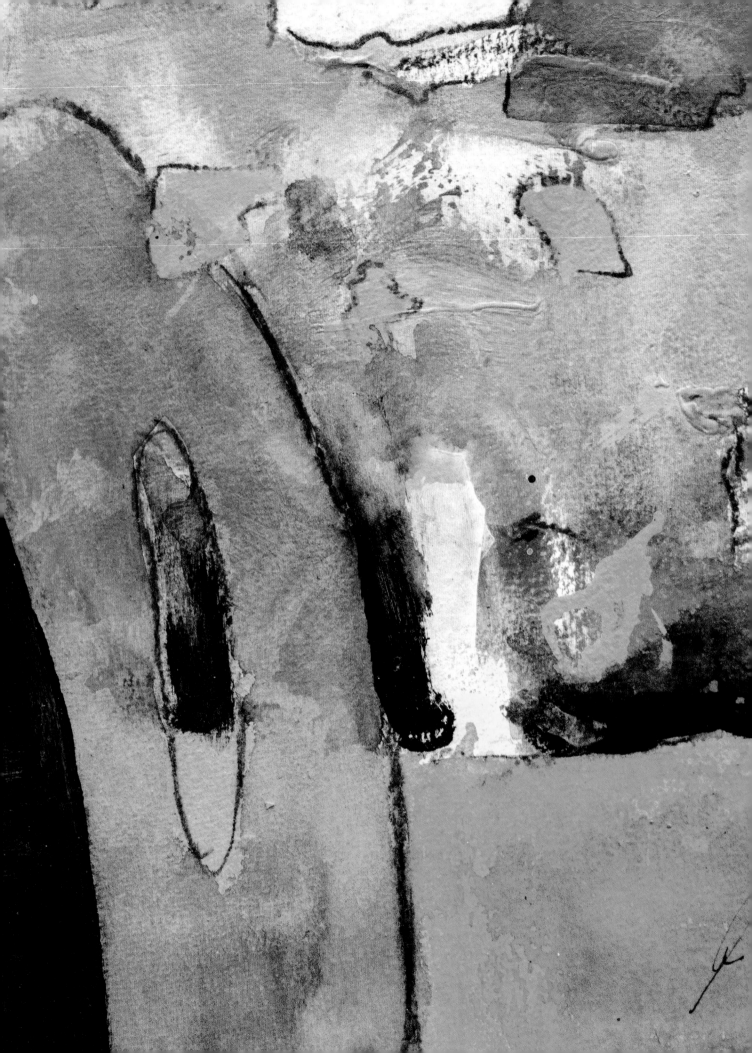

Impasto and Glaze on an Underpainting

TASK AND MATERIALS

Focal points

Colour, space, line, form, dynamics, variation, contrast

Equipment

Flat brush, spray bottle

Materials

Stretched canvas: 60 x 60cm (23½ x 23½in), charcoal

Acrylic paints: Titanium White, Black, Warm Grey, Magenta, May Green, Yellow, Yellow Ochre

Aero Color: Golden Ochre

Original format

INSTRUCTIONS

The underpainting was created from leftover Magenta, Yellow and Titanium White paints from another picture. Opaque overlays of Warm Grey, Yellow Ochre and May Green are applied freely in some areas, leaving only a shimmer or a small area of the lower layer visible. Using fragmented outlines, the resulting forms were accentuated with charcoal. The oval shape in the Golden Section and part of the green space in the lower-right third were given a glaze in Golden Ochre. Finally, a new space was created in Black, which was interwoven with the oval form to create a clear outline.

Clear view of the underpainting

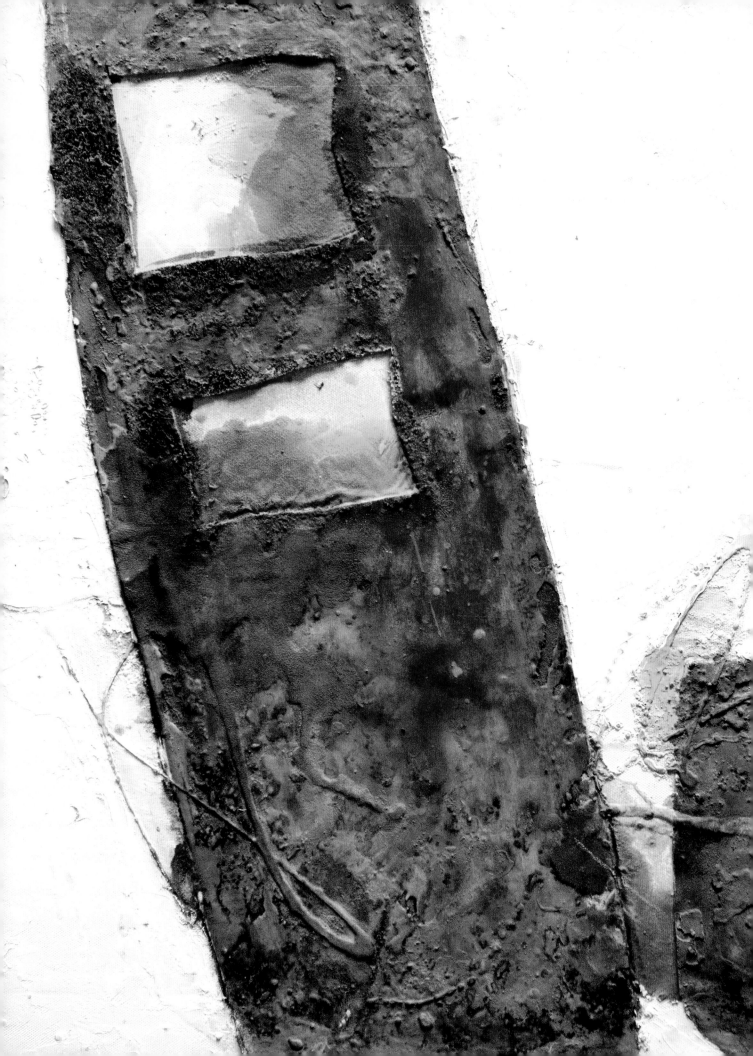

Positive and Negative Stencil

TASK AND MATERIALS

Focal points

Colour, space, line, dynamics, variation, contrast

Equipment

Spatula, flat brush

Materials

Stretched canvas: 60 x 60cm (23½ x 23½in), creamy acrylic binder, silica sand, grey packaging paper

Acrylic paints: Titanium White, Burnt Sienna, Black

Original format

INSTRUCTIONS

Place a 20cm (8in)-wide strip of packaging paper onto the line of the left vertical third. With the flat brush, apply creamy acrylic binder spontaneously and swipe out the residues onto the painting support medium and the packaging paper so that linear traces are created. Sprinkle silica sand over all the surfaces; it will only stick in the areas of the wet binder. With a dynamic pouring motion, glaze the entire surface with diluted Burnt Sienna. Remove the packaging paper and glaze it with Black. Next, cut rectangular forms from the paper strip and stick both the cut-out form and the strip onto the painting support. Finally, calm the picture by covering large spaces in opaque Titanium White with the spatula.

Serial work with stencils is great fun, and offers ever-changing possibilities of image design.

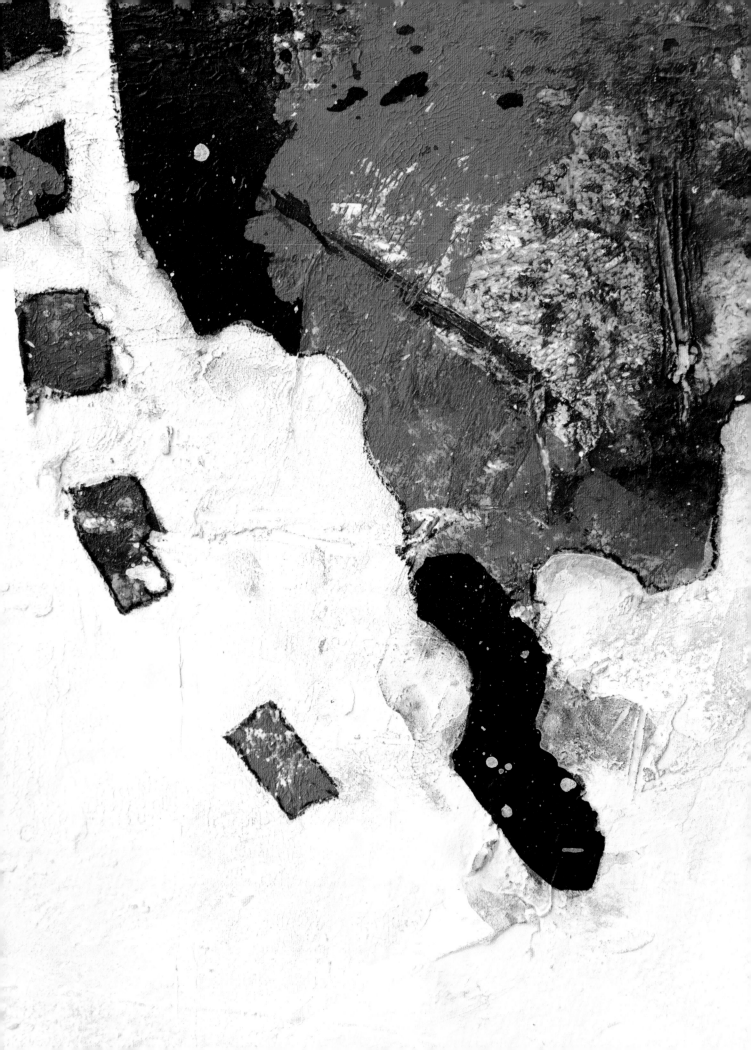

Negative Form through Glazing

TASK AND MATERIALS

Focal points

Colour, space, line, pattern, dynamics, variation, contrast

Equipment

Rubber roller, spatula, flat brush

Materials

2 stretched canvasses: 60 x 90cm (23½ x 35½in), texture paste, charcoal

Acrylic paints: Hooker's Green, Burnt Sienna, Burnt Umber, Pebble Grey, Black

Aero Color: Supra White

Original format

INSTRUCTIONS

Work on both canvasses simultaneously. With the spatula, freely apply paste to the central area of both canvasses. Leftover paints (here Hooker's Green and Supra White) from another painting have been used as an underpainting without any planning. Apply Burnt Umber with the rubber roller in spontaneous motions over a large part of the surface. Repeat with Burnt Sienna but restrict yourself to a rolled trace in the central area. Pour diluted Black sweepingly over the picture diagonally. Outline the rectangles with charcoal; similar to windows in a wall, they provide a view of the background. Then, calm the work by glazing slightly more than half of the total surface with diluted Pebble Grey, avoiding the rectangles. Finally, border the edges of the glaze with fragmented charcoal outlines.

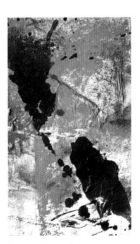

Interim stage I

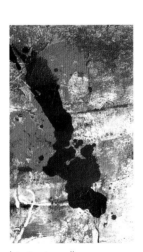

Interim stage II

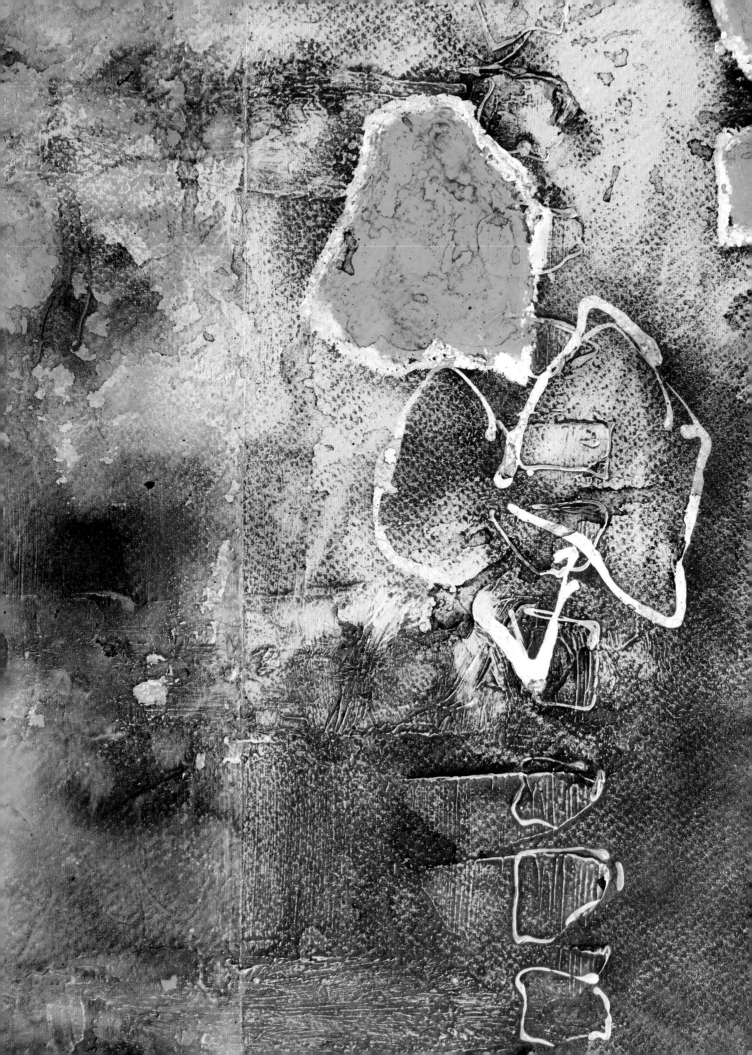

Free Forms in the Golden Section

TASK AND MATERIALS

Focal points

Colour, space, line, pattern, variation, contrast, balance

Equipment

Spatula, flat brush, spray bottle, dosing bottle, masking tape

Materials

Stretched canvas: 60 x 70cm (23½ x 27½in)

Acrylic paints: Royal Blue, Burnt Umber, Cobalt Turquoise, Vandyke Brown, Gold

Aero Color: Supra White

Original format

INSTRUCTIONS

The underpainting was painted on without any planning using leftover paints in Burnt Umber and Cobalt Turquoise, with stripes in Royal Blue applied with the spatula. Calm the background using a Vandyke Brown glaze running from right to left. Using the thin nozzle of a dosing bottle, draw a line of loose squares in Cobalt Turquoise dividing off the right third. With Supra White, draw free forms into the area of the upper right Golden Intersection and fill in three of them with a glaze. Using a dry granulation in Gold, highlight the tactility of the underlying paint texture over the entire surface. First, cover the white patches with Royal Blue. Cover the left third of the picture with masking tape, and glaze the separated space and the three patches with Cobalt Turquoise. After removing the masking tape, combine the individual picture elements by splattering very diluted Vandyke Brown over the entire surface.

Interim stage I

Interim stage II

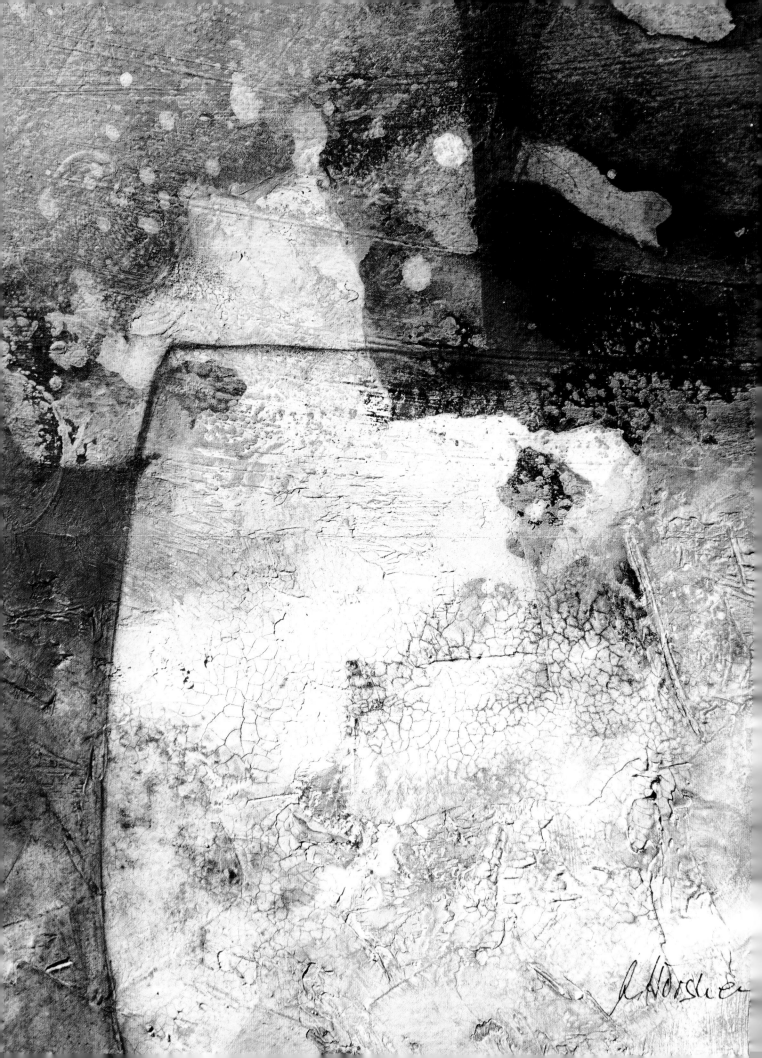

Large and Small Forms

TASK AND MATERIALS

Focal points

Colour, space, line, variation, contrast

Equipment

Pencil, spatula, flat brush, spray bottle

Materials

Stretched canvas: 60 x 90cm
(23½ x 35½in), crackle paste, charcoal,
acrylic binder, fixative

Acrylic paints: Yellow Ochre, Gold

Aero Colors: Supra White,
Turquoise, Sepia

Original format

INSTRUCTIONS

Use the pencil to engrave various scribble marks into the opaque Yellow Ochre underpainting while it is still damp. With the spatula, starting at the bottom edge of the picture, spread crackle paste over slightly more than a third of the surface. First, splatter the entire picture with Sepia and spray the edges; then pour Supra White over the cracked texture and knock out the residues with a brush. Use the spatula to granulate the Gold freely in the central area of the picture. Sketch two large, clearly overlapping forms in charcoal and shade the remaining background in the bottom left by rubbing in charcoal dust with your fingers. Glaze the remaining background – top right – with Turquoise, apart from two small shapes. Finally, spray the charcoal with fixative and apply some acrylic binder to the upper half of the picture to increase the gloss in this area.

TIP

Gold is effective on all dark backgrounds; alternatively, use the classic dark red shades found in gilding as an underpainting.

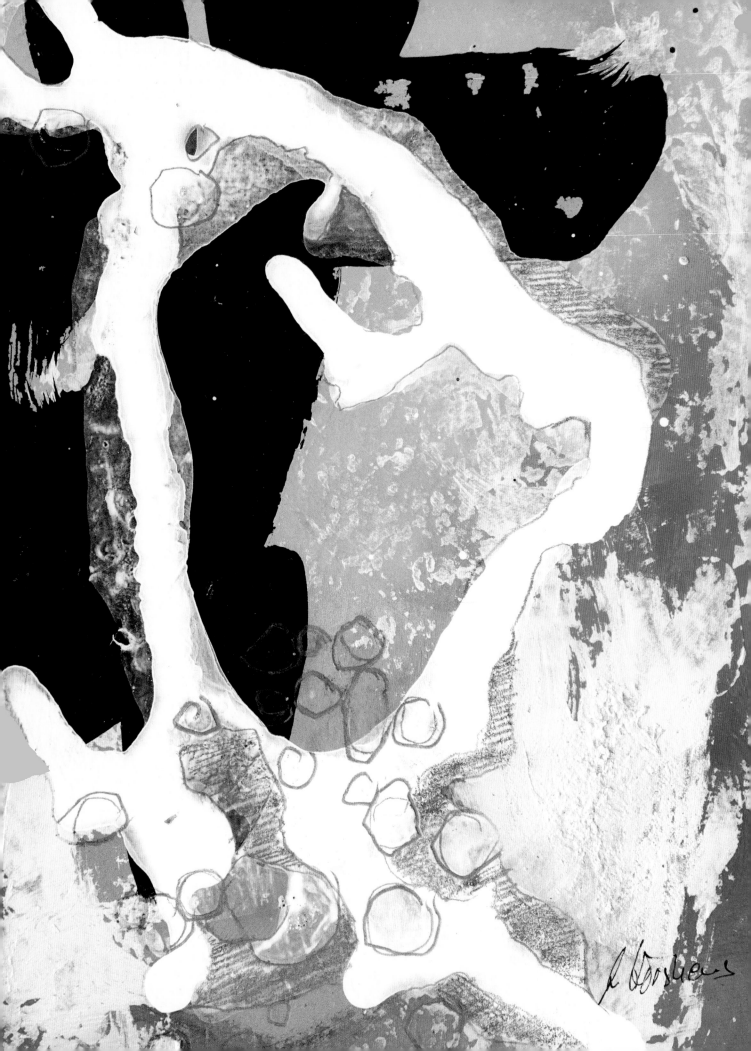

Freely Poured Forms

TASK AND MATERIALS

Focal points

Colour, space, line, form, dynamics, variation, contrast

Equipment

Spatula, flat brush, dosing bottle, pencil

Material

Stretched canvas: 60 x 90cm (23½ x 35½in), acrylic binder

Acrylic paints: Yellow Ochre, Arctic Blue, Primary Cyan, Green Yellow, Black, Silver

Acrylic sprays: Green Yellow, Magenta

Original format

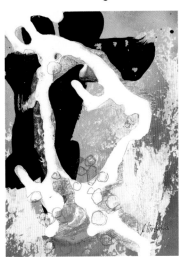

INSTRUCTIONS

On an opaque underpainting in Yellow Ochre, splatter various spots of slightly diluted Green Yellow from a dosing bottle. Paint a granulating Cyan from the upper and lower edges of the picture. Spray a smaller space with Magenta and a space at least twice as large with Green Yellow. Connect the edges of the individual colour patches by granulating Silver over them with the spatula. Paint opaque Black into the area of the upper-left Golden Section freely with the flat brush. Paint the entire picture with a thin layer of acrylic binder in order to increase the gloss. Pour slightly diluted Arctic Blue into the upper-left corner and allow the paint to run freely by turning and flipping the painting support medium. Finally, outline individual spots from the background with a pencil and hatch various glazed streaks and circles.

Green Yellow spots on the underpainting

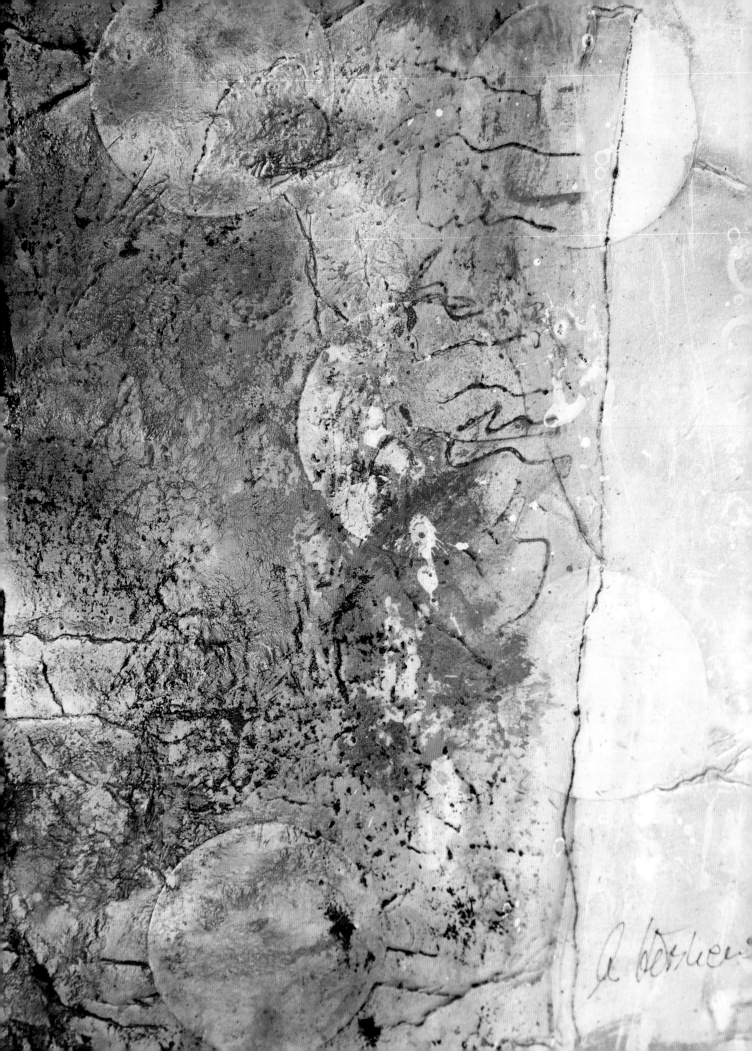

Circles in a Negative Stencil

TASK AND MATERIALS

Focal points

Colour, space, line, form, harmony, contrast

Equipment

Spatula, flat brush, dosing bottle, circle cutter

Materials

Stretched canvas: 60 x 80cm (23½ x 31½in), acrylic binder, Chinese paper

Acrylic paints: Titanium White, Orange, Madder Red Deep, Warm Grey, Black

Original format

INSTRUCTIONS

In the central area of the picture are some barely perceptible leftovers of Madder Red Deep. Using a dosing bottle with a thin nozzle and some slightly diluted Black, write some illegible text over about two-thirds of the picture area. Granulate some Warm Grey from the left edge of the picture over the delineated area and swipe out the diluted paint residues with the brush. With a circle cutter, cut out circles of equal size from the Chinese paper and collage the remaining paper stencil with acrylic binder in minimal, subtly arranged folds. Take up some Orange with the spatula and granulate over the central area of the picture; starting from the left edge of the picture, repeat the process with Black. The paint sticks in the folds of the paper and the cut edges of the circles, emphasizing their tactile qualities. Glaze the entire picture with a very diluted Warm Grey. Finish with a milky tinted glaze and some splashes of colour in Titanium White.

TIP

Alternatively, use opaque paper for collaging by cutting out so many circles that only small ridges remain.

Interim stage

PATTERN

Nature is an expert in employing the most diverse patterns. Natural surfaces are enlivened by rhythmically arranged dots, ovals and diamonds or irregular spots and lines, which both haptically protrude and create a sense of depth. An endless variety of three-dimensional surfaces, such as velvety, granulated, wavy, smooth, rough, cracked or grooved, influences the refraction of light and thus the colour effect.

STIMULI

The detail found in nature provides an endless variety of ideas, both for abstract forms and for their arrangement for a possible picture layout. You can easily supplement the following examples from your own observations of nature.

PRACTICE

Bring your spaces to life in a series of patterns, such as triangles. Draw using various pens or paint with a brush. Let your imagination run free. You will keep discovering new patterns over time.

Tree bark

Small circles

Stones

Overlapping ovals

Lichen on rocks

Triangles

STAMPS

Acrylic paint is excellent for all kinds of printing or stamping techniques. Repeated imprints are a wonderful way to enliven an image.

STIMULI

- Impression of embossed paper or textured wallpaper
- Patterned rollers from the specialist painter's shop
- Self-made or purchased stamps
- Bubble wrap

PRACTICE

Before using the roller, roll the acrylic paint out thinly on a sheet of glass in order to colour the roller evenly and avoid unwanted irregularities. Place paper or film with the side to be used for printing upside-down into the rolled-out paint in order to pick it up. Then roll, press or stamp the paint onto the dry surface.

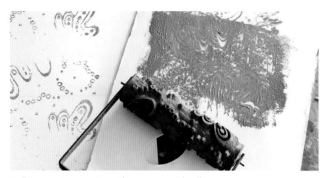

Roll on pastose paint with a patterned roller.

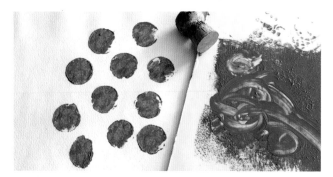

Stamp using everyday objects, such as a champagne cork.

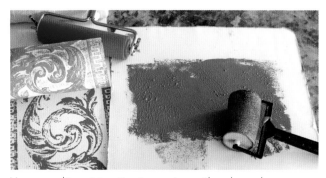

You can achieve interesting impressions with embossed paper.

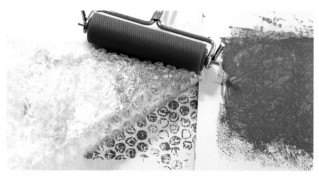

Colour bubble wrap with pastose paint and press it on.

STENCILS

Purchased, self-cut or torn stencils made of cardboard, foil, or paper are ideal for serial repetition of a shape or a more complicated pattern. Place the stencil on the painting surface and fill in the empty spaces. To protect some areas of your picture from overpainting, mask off the spaces that are to be left blank. You can achieve precise edges with masking tape.

- Make stencils from packaging paper for repeated shapes and patterns.
- Place a grid or perforated sheet on the painting support and spray over it with spray paint or varnish. The higher the colour contrast between the spray paint and the background, the more effective these paint textures become.

- Use masking tape to create a composition with sharp edges. By using so-called painter's tape, you can delimit spaces and mask off perfect straight lines and clean edges. Liquid paint often penetrates under the edges of the masking tape. Insulate the edge by first applying a thin layer of acrylic binder over the edge of the masking tape and letting it dry so that no paint can seep under it.
- Cover areas that should remain untouched during an application with newspaper or self-made cardboard stencils. This is particularly effective with spray techniques, as the spray coverage can never be clearly defined.
- Stencils for decorating furniture and walls offer the possibility of integrating patterns or motifs into your pictures.

Roll with a lambswool roller.

Sharp edge using masking tape

Dab with a sponge.

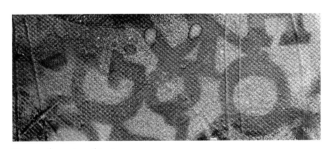

Sprayed-on stencil textures

Stipple with a brush held in an upright position.

Tactile impressions of a lettering stencil

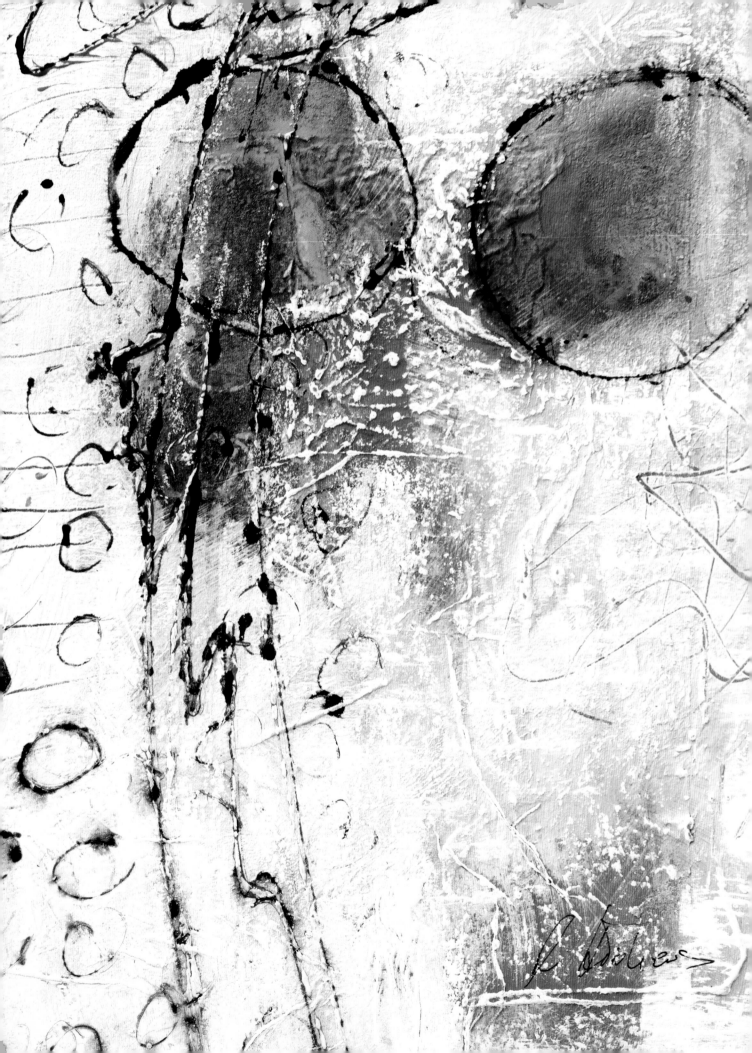

Linear Pattern on Collage

TASK AND MATERIALS

Focal points

Colour, space, line, form, pattern, variation, contrast

Equipment

Flat brush, dosing bottle, pencil

Materials

Stretched canvas: 60 x 80cm (23½ x 31½in), tissue paper, packaging paper

Acrylic paints: Titanium White, Green Yellow, Cadmium Red, Primary Magenta, Primary Cyan, Black

Acrylic spray: Magenta

Oil pastel: Titanium White

Original format

INSTRUCTIONS

A tissue paper collage is laid in the background, which has been worked over in multiple glazes in Primary Cyan, Magenta and Green Yellow. Cut two circles from packaging paper and place these as a stencil in the upper third of the painting support. Spray Magenta next to the treated space as well as over large parts of the picture and remove the stencils. Glaze Titanium White on in loose brushstrokes, but without completely covering the sprayed layer, and scribble into the damp paint with a pencil. Using Cadmium Red in the dosing bottle, draw illegible textures and curved lines onto the line of the left vertical third. Repeat this process with slightly diluted Black. In addition, draw small circles over the left vertical third line. Use the Titanium White oil pastel to granulate over the tactile folds of the underlying collage without applying any pressure.

The elaborate underpainting is only visible in the cut-out circles at the end.

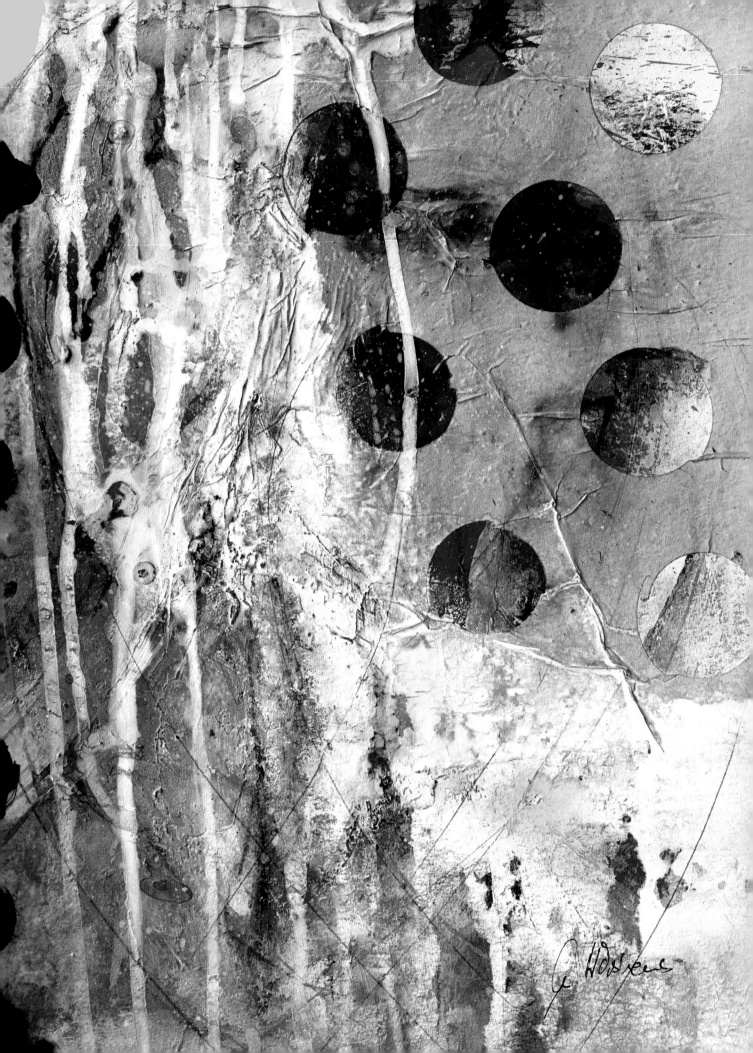

Circular Pattern

TASK AND MATERIALS

Focal points

Colour, space, line, form, pattern, repetition, motion, balance, harmony

Equipment

Spatula, pencil, flat brush, circle cutter, spray bottle, champagne corks, dosing bottle

Materials

Stretched canvas: 40 x 50cm (15¾ x 19¾in), grey packaging paper, acrylic binder

Acrylic paints: Ivory, Royal Blue, Pebble Grey, Cadmium Red, Cobalt Turquoise, Black

Aero Colors: Titanium White, Supra White, Black

Original format

INSTRUCTIONS

Beginning with an Ivory underpainting, paint Cadmium Red and Royal Blue freely over the main area of the upper two-thirds. Apply a glaze in Pebble Grey, leaving enough space untreated to allow a view of the lower layers. Using the dosing bottle, draw curved lines in Cobalt Turquoise and Black, following the original motif. Cut circles from the packaging paper using the circle cutter. To start with, arrange the collage and try things out. Only when you are happy with the composition should you stick down the pieces with acrylic binder. Using the spatula, apply Titanium White from the bottom edge, granulating upwards, and repeat the scribbling with the pencil. Glaze some areas with Supra White. Place the painting support medium upright to allow the traces to flow downwards, and spray around the edges with water. Finally, stamp a vertical row of dots in opaque black acrylic paint on the left edge of the picture, using a champagne cork.

This drawing is the original model for the picture. In the draft, the outlines of two sketched horses have been lengthened along the natural curvature in order to develop a new, abstracting language of form.

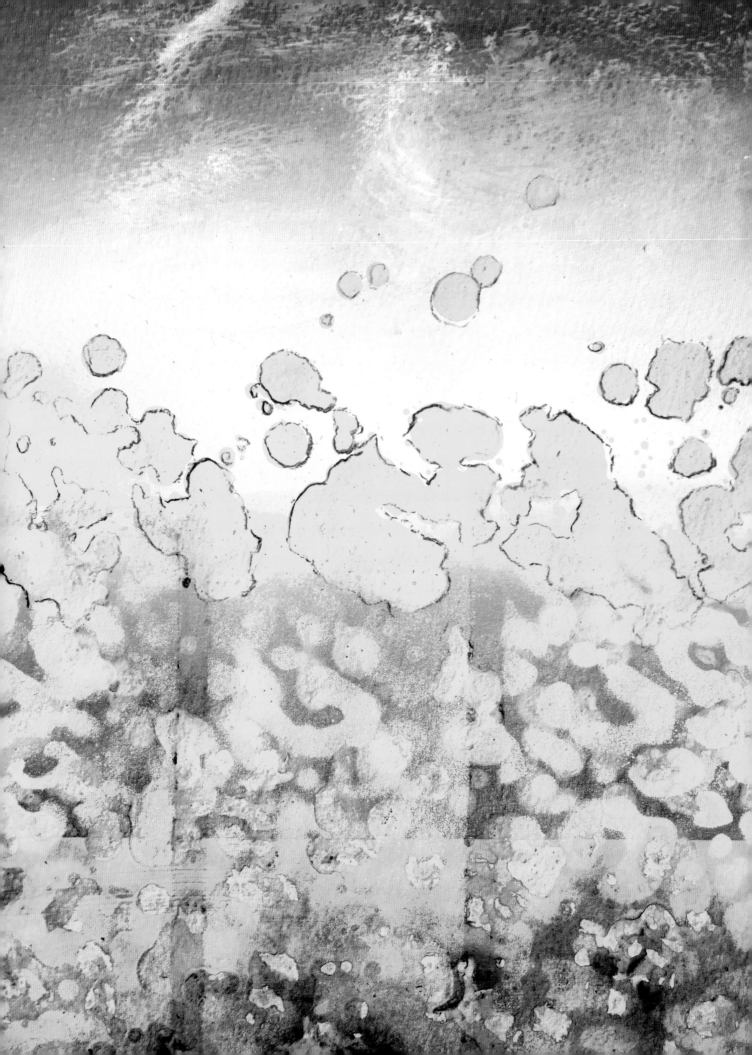

Sprayed Stencils Pattern

TASK AND MATERIALS

Focal points

Impasto, gradation, pouring, colour, space, pattern, variation, contrast

Equipment

Flat brush, dosing bottle, stencil, masking tape, spray bottle

Materials

Stretched canvas: 50 x 80cm (19¾ x 31½in), charcoal

Acrylic paints: Primary Yellow, May Green, Hooker's Green, Cobalt Blue, Primary Cyan, Titanium White, Yellow Ochre, Vandyke Brown

Acrylic spray: Indian Yellow

Original format

INSTRUCTIONS

This piece was developed from an original landscape study. Use Cobalt Blue, Titanium White and a final splash of Cyan to shape the upper third. Paint the middle third in Titanium White, Yellow and Hooker's Green. Cover the edge of the lower third with masking tape and paint the space in an opaque Yellow Ochre. Apply a stencil with small patterns and spray Indian Yellow into the gaps. Dilute May Green and some Yellow in a dosing bottle and splatter different-sized splotches over the lower two-thirds of the picture. Starting from the lower edge of the picture, glaze with very diluted Vandyke Brown and spray the edges softly upwards with water. Finally, emphasize some of the green-yellow splotches with fragmented charcoal outlines.

Interim stage I

Interim stage II

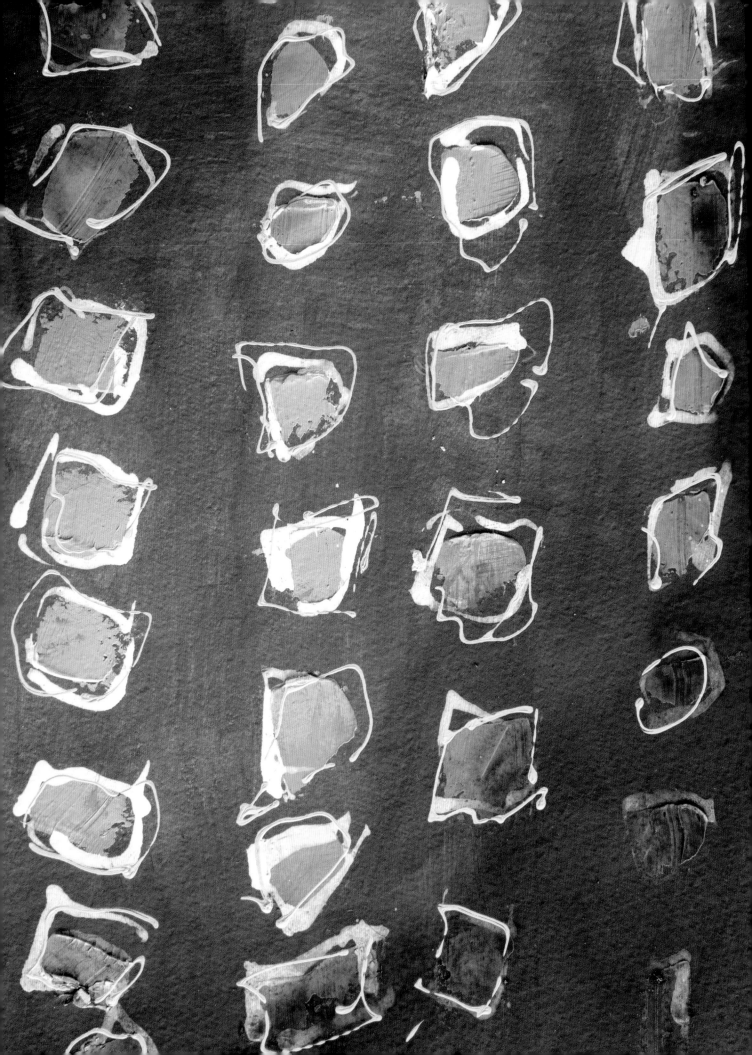

Freehand Pattern with a Spatula

TASK AND MATERIALS

Focal points

Colour, space, pattern, variation, contrast

Equipment

Spatula, flat brush, dosing bottle

Material

Stretched canvas: 50 x 80cm (19¾ x 31½in)

Acrylic paints: Cobalt Turquoise, Royal Blue, Vandyke Brown, Arctic Blue

Aero Color: Supra White

Original format

INSTRUCTIONS

Apply the underpainting in two transparent layers with the flat brush, leaving the brush marks clearly visible. A glaze in Cobalt Turquoise is applied after Vandyke Brown. Use the spatula and Royal Blue to create roughly equally sized splotches in four vertical lines.

Outline the splotches loosely in Supra White. Starting from the upper-left and lower-right corners, glaze some areas again with Vandyke Brown and shade over about half of the colour splotches. Using Arctic Blue in a dosing bottle with a very fine nozzle, outline the colour splotches again with dynamic lines. Be careful not to follow the existing outlines exactly or to frame the splotches.

TIP

An inherently monochrome and lacklustre space is illuminated by the blotchy pattern.

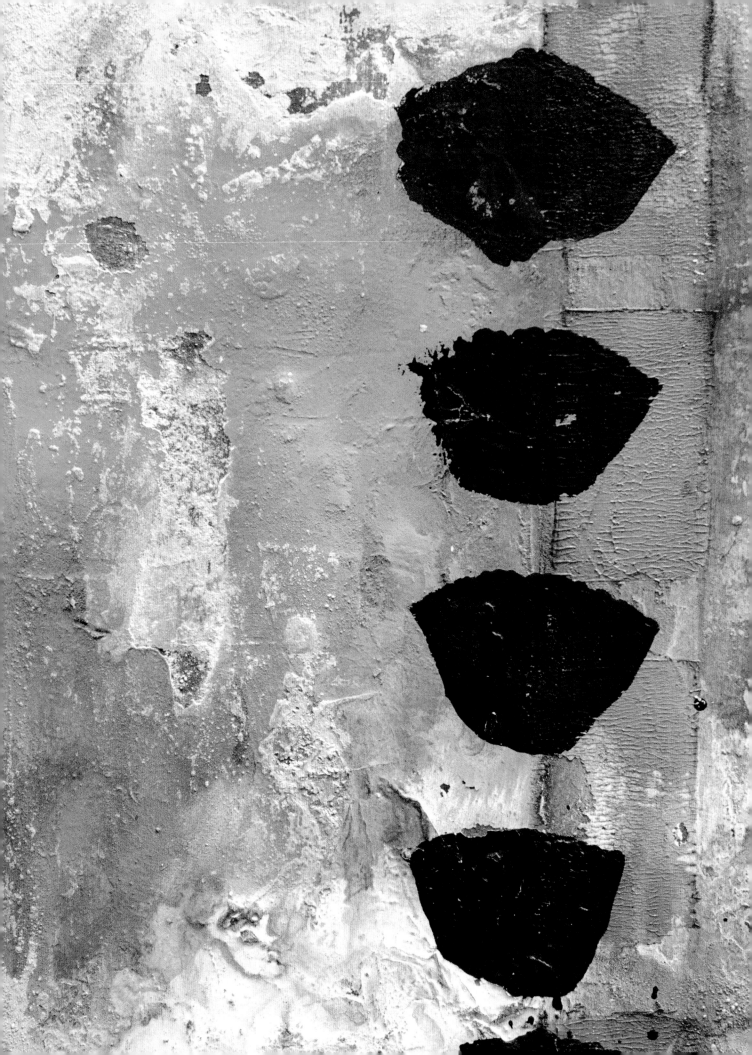

Pattern on Texture

TASK AND MATERIALS

Focal points

Colour, space, line, texture, variation, dynamics, motion, contrast

Equipment

Spatula, flat brush, cat's tongue brush, hard rubber roller

Materials

Stretched canvas: 40 x 60cm (15¾ x 23½in), light texture paste, ash, acrylic binder, tissue paper, charcoal

Acrylic paints: Titanium White, Silver, Raw Sienna, Hooker's Green, Black

Acrylic spray: Green Yellow

Original format

INSTRUCTIONS

Collage tissue paper with acrylic binder and work over the entire picture surface in a loose, fragmented application of texture with paste and ash. Onto a primary opaque layer of Raw Sienna, first pour very diluted Hooker's Green and then Titanium White. With the hard rubber roller, roll upwards to create a strip of vertical rectangles in the area of the right third of the surface, and subtly outline it with charcoal. Spray just over a third of the surface with Green Yellow acrylic spray. Using the spatula, granulate Silver from the edges of the picture inwards. Repeatedly press down a cat's tongue brush loaded with slightly diluted Black to create a border on the line of the right-hand third. The lustrous character of the picture is achieved by a final thin coat of acrylic binder.

New picture planes through multiple glazes.

Sprayed Green Yellow calms the area.

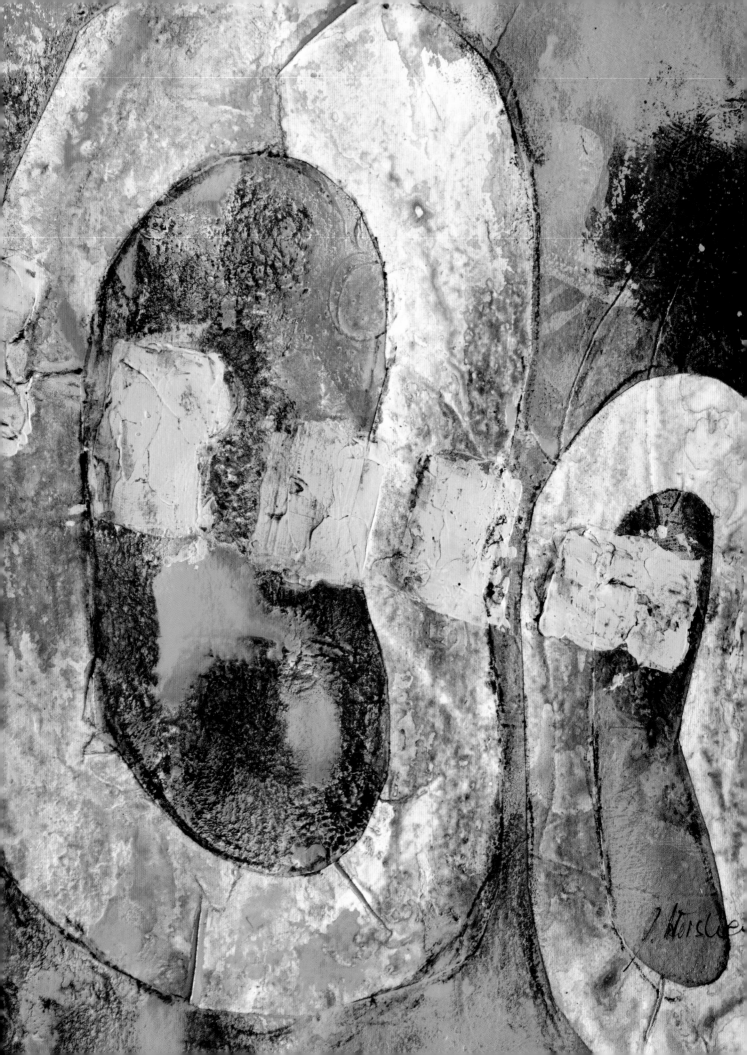

Collage of a Paper Stencil

TASK AND MATERIALS

Focal points

Colour, space, form, line, variation, contrast

Equipment

Spatula, flat brush, hard rubber roller, dosing bottle, pipette, spray bottle

Materials

Stretched canvas: 50 x 70cm (19¾ x 27½in), charcoal, acrylic binder, brown packaging paper

Acrylic paints: Primary Cyan, Yellow Ochre, Black, Gold

Aero Colors: Light Grey, Primary Blue Cyan

Oil pastel: Turquoise

Original format

INSTRUCTIONS

Using thick, diluted Cyan in a dosing bottle, pour a free trace of colour onto the opaque underpainting in Yellow Ochre. With the flat brush, apply two large spots of black impasto from the left and right edges of the picture; then, roll over the applied paint with the hard rubber roller, thus changing the surface texture of the paint. Cut two oval stencils of different sizes from packaging paper and glue these on with acrylic binder. Using the oil pastel, highlight two areas in the right third, starting from the upper and lower edges of the picture.

Then, follow up with glazes in Light Grey and Cyan; apply each colour with the pipette in lines and splotches, and spray the edges with water. Use the spatula to create a diagonal strip of rectangles in Gold. Finally, reinforce the edges of the stencils and the golden rectangles with fragmented outlines in charcoal.

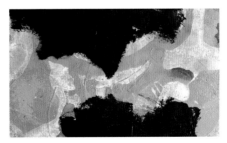

Underpainting before the collage

TIP

Free-hand cut shapes are suitable for collage on agitated surfaces; the large monochrome forms are calming and create an additional picture plane.

REFLECTING

Discussing pictures is an important part of my seminars. In order to evaluate the work, to bring order into chaos or to identify elements that do not fit, it is extremely important to observe it from a suitable distance. Look at your picture standing on an easel or even hanging on the wall. Take your time to look at the picture and let it take its effect on you. If you are alone, it is best to have some self-talk with your work. Question your work with regard to its compositional principles and evaluate its effect by checking the contrasts. Some pictures are too exciting; others lack tension. If the contrasts are too strong, cover individual elements of the picture with your hand in order to decide whether they are suitable or should be dispensed with. If the picture seems boring and bland, increase the contrasts. Although spatial perspective or object-related three-dimensionality are not the aim of abstract works, there may be a before/behind or an over/under effect to create more visual depth. Alongside all the principles to be checked, it is also, ultimately, a question of taste.

COMPOSITION

Lines, spaces and forms are evaluated according to opposites:

- Large – Small
- Many – Few
- Thick – Thin
- Line – Space.

COLOUR PHILOSOPHY

The interaction of the colours is evaluated using colour contrasts:

- Light – Dark
- Cold – Warm
- Perfect – Broken
- Vivid – Pastel
- Complementary contrast
- Quantity
- Colour tone.

VISUAL DEPTH

Visual depth is evaluated using a number of attributes:

The following are effective for the foreground:
- Detail (forms – sharp outlines)
- Intensity (colourfulness and pure shades)
- Texture (exciting vivacity)
- Eye-catcher (red)
- Contrast (large differences).

The following are effective for the background:
- Paleness (white refraction of the shades)
- Dullness (varying shades)
- No outlines (space – soft transitions)
- Blurriness (glaze).

The painting process consists of many steps – construction and destruction are part of the development process for your own pictures. Often there is no direct path to the destination. In between, there are often frustrating intermediate stages, which are finally solved with new approaches to thinking. The creative process is a constant rotation of:

- construction
- destruction
- rearranging
- rotating
- turning upside-down
- overpainting
- maintaining
- reducing
- consolidating
- streamlining
- stimuli.

SUGGESTIONS

Serial working reduces the pressure to succeed – your need for a good picture is spread over several canvasses. Adopting variations of the same approach, work simultaneously on three or more stretcher frames, in order to arrange the composition of the individual elements differently in each picture. If you are stuck, you can try the following possibilities:

- Calm some of the spaces, for instance by overpainting with a uniform application of opaque paint.
- Stick paper over some areas.

ABOUT THE AUTHOR

Anita Hörskens lives and works as a freelance artist and is the head of her own painting school in Pfaffenhofen-an-der-Ilm in Bavaria. She has worked as a trainer and a speaker in the field of artists' supplies since 1994. She leads seminars in all standard painting and drawing techniques, and offers painting holidays, portfolio preparation courses, and creative seminars for companies.

As the author of numerous acrylic textbooks, she has also lectured at various specialist academies since 2004, with a focus on experimental mixed techniques with acrylic. In her blog, she regularly reports on her News from the Studio.

www.hoerskens.blogspot.de
www.hoerskens.de

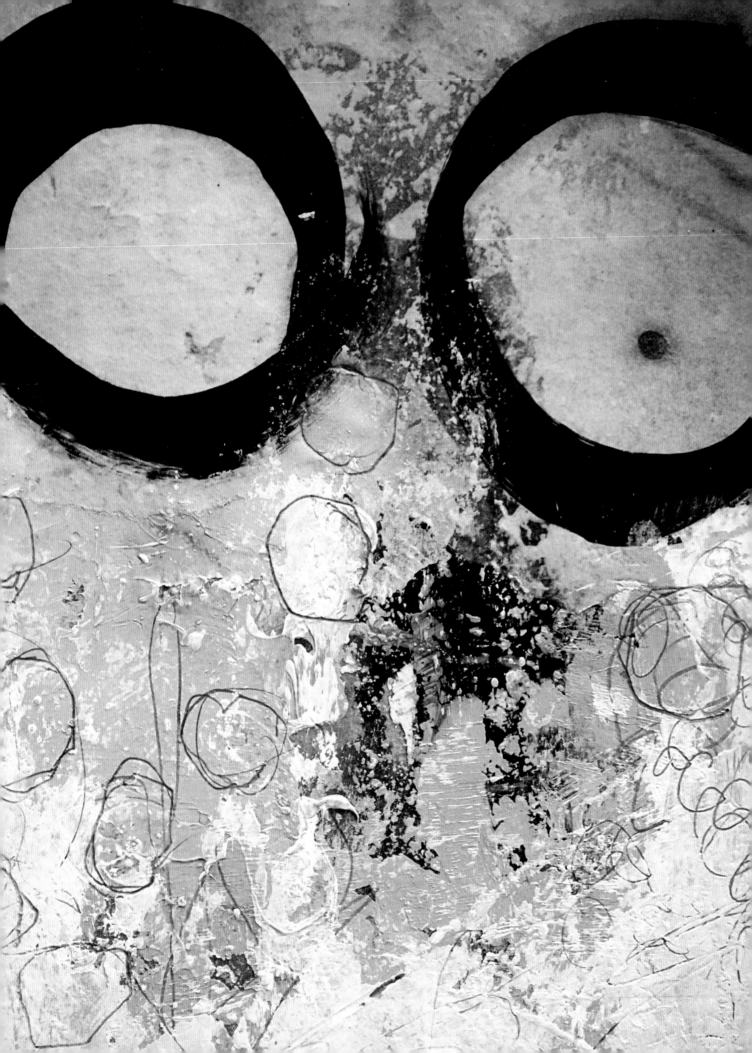